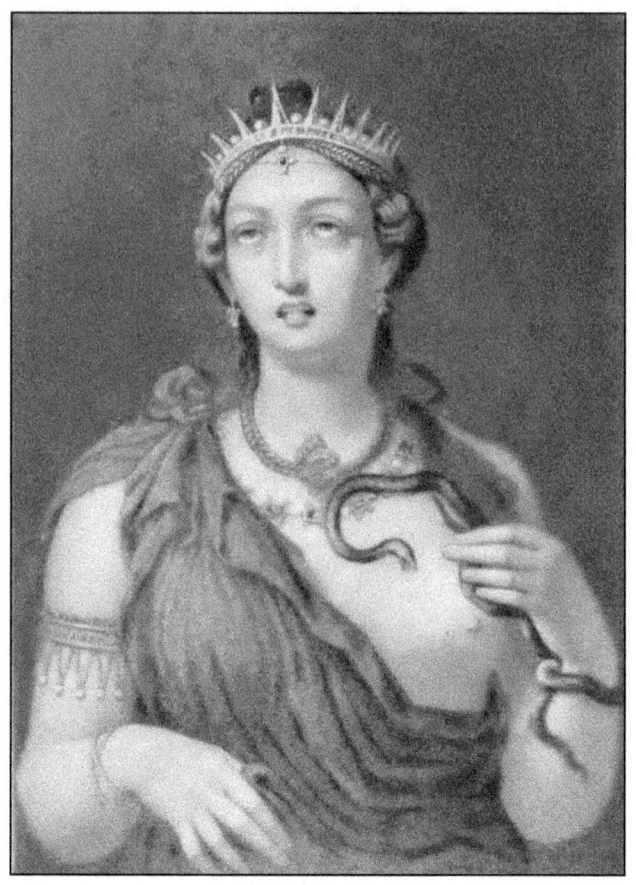

ON STEEL BY JOHN SARTAIN, FROM THE ORIGINAL
PAINTING IN ENCAUSTIC AT SORRENTO NEAR NAPLES IN
THE POSSESSION OF THE BARON DE BENNEVAL

CLEOPATRA RECEIVING HER DEATH
FROM THE BITE OF AN ASP

Discovered in the ruins of Hadrian's villa and believed to the picture painted for the Emperor Augustus, to adorn his triumph BC 29, the queen herself having escaped that degradation by suicide.

ON THE

ANTIQUE PAINTING

IN ENCAUSTIC OF

CLEOPATRA

DISCOVERED IN 1818.

By
John Sartain

Originally published in Philadelphia in 1885.

On the antique painting in encaustic of Cleopatra discovered in 1818.

By John Sartain.

Originally published in Philadelphia in 1885.

This edition 2023

Scrawny Goat Books

124 City Road

London EC1V 2NX

United Kingdom

scrawnygoatbooks.com

ISBN 978-1-915645-28-9

Contents

About the Author vii

Introduction. 1

The Fine Arts. 21

An Inquiry into the Art of Painting Encaustic as Practiced by the Ancients, and on the Antique Picture of Cleopatra in the Possession of the Baron De Benneval, at Sorrento. 26

List of Illustrations

Cleopatra Receiving Her Death from the Bite of an asp.	*Frontispiece*
The Author.	vii
Cortona, as Seen from the Foot of the Hill.	7
Lake Thrasymene, as Seen from the Heights of Cortona.	9
The Muse of Cortona.	11
Canopy of the Temple of Serapis, Hadrian's Villa.	13
Villa Benneval, Piano Di Sorrento.	15
Cleopatra on the Cydnus, on Her Way to Meet M. Anthony. (After Mackart).	20

...../continued

List of Illustrations (continued).

First Meeting of Anthony and Cleopatra, a Photo-Gravure. (After G. Weitheimer).	25
Part of the Imperial Palace, Hadrian's Villa	27
Another Part of the Imperial Palace, Hadrian's Villa	28
The Library, Hadrian's Villa	30
Temple of the Philosophers, Hadrian's Villa	32
Exedra, and Piazza of the Army, Hadrian's Villa	34
Logge for Spectators, Hadrian's Villa	37
Maritime Theatre, Hadrian's Villa	39
Baths for Women, Hadrian's Villa	41
Baths for Men, Hadrian's Villa	42
Temple of Bacchus, Hadrian's Villa	45
Part of the Hundred Chambers, Hadrian's Villa	47
Cleopatra Coin Preserved in the British Museum	50
Cleopatra, from the Carving on the Pronaos of the Temple At Dendera, Egypt.	51
Portion of a Roman Triumph. (After the Andrea Mantegna, At Hampton Court Palace.)	54
Portion of A Roman Triumph. (After the Andrea Mantegna, At Hampton Court Palace.)	55
Death of Mark Anthony. (After Mieris).	60
Death of Cleopatra. (After Mieris).	61

About the Author

John Sartain (1808 – 1897) was born in England and at an early age learned the art of line engraving, quickly making a name for himself in his hometown of London, particularly in the artistic movement known as the "Early Florentine School."

By 1828, he had mastered the art of mezzotint printmaking, an advanced artistic technique which entails the fine working of a metal printing plate with thousands of little dots to create tonality and an image when printed. This was a major advance on the until then use of stripes or hatches in metal plate printing and allowed for a much smoother print quality.

Armed with this new skill, Sartain moved to the United States in 1830, and settled in Philadelphia. He quickly found employment in portraiture, bank note design, and book illustrations, becoming the first mezzotint engraving artist in America.

THE AUTHOR.

His work also appeared in a number of famous publications, and he became the established master of his craft in the United States. By 1848, he had his own journal, called Sartain's Union Magazine. His skill also allowed him to become prominent in artistic circles in America, and he held positions in the Artists' Fund Society, the School of Design for Women, and the Pennsylvania Academy of Fine Arts.

He was also in charge of the art department of the Centennial Exposition in Philadelphia, in 1876. The King of Italy was so impressed with his work there that he awarded Sartain the title of cavaliere of the Order of the Crown of Italy.

It was during this time that he visited Europe many times, and took up an interest in the painting of Cleopatra which forms the subject of this book. During one of his visits to Europe in 1862, he was elected a member of the society "Artis et Amicitiæ" in Amsterdam.

Sartain was also an accomplished architect, and contributed towards the Washington Memorial in Fairmount Park, Philadelphia, and designed the medallions for the 1869 monument to George Washington and Lafayette in Monument Cemetery, Philadelphia. In 1897, the Philadelphia School of Design for Women created the John Sartain Fellowship in recognition of his 28-year tenure as Director.

Sartain died at the age of 89 and was buried in Monument Cemetery. Sadly, the cemetery fell into disrepair, and in 1956 was given to Temple University for use as a parking lot. Sartain's remains were among 20,000 others not claimed and re-interred in a mass grave at Lawnview Cemetery.

All the tombstones, including the cemetery's 70 feet high central monument to George Washington and General Lafayette and his family monument (all designed by Sartain) were dumped into the Delaware River to serve as the foundations for the Betsy Ross Bridge.

Introduction

IN 1818, a lumber merchant tasked with removing scrap wood from the land which had been the Emperor Hadrian's villa outside Rome, discovered a wooden crate among the lumber on the estate. The crate was carefully opened. Inside was a broken slate tablet with an overlay of dimly visible colors underneath a thick and dust-encrusted varnish. It was difficult to discern the image, but the 16 pieces fit together like a puzzle.

Painters were called in to remove the thick, mottled layers of varnish. Colors with an amazing brilliance and polished finish began to emerge. The astonishing picture slowly revealed a figure of a young, beautiful woman clad in a crimson tunic, with a jeweled golden crown. Matching the crown were a set of earrings, necklace and pendant on her forehead that were inlaid with rubies and emeralds, and the jewelry had fine pearls mounted on the edges. A gold armband with pearls suspended on gold chains and a bracelet of gold were on her right arm.

But the painting had another, more startling aspect- the young woman had a serpent coiled around her left forearm, and it was in the very act of striking her on the exposed left breast. A pair of puncture marks from a previous strike seeped blood. Her expression was one of profound grief and turmoil. Tears flowed from her sorrowful, upturned eyes. The parted lips revealed the tongue pressed forward between the teeth, as if the serpent's poison was swiftly taking effect.

The Royal person so vividly portrayed could only be Queen Cleopatra, the last Pharaoh of Egypt, consort of Julius Caesar before his assassination and, in later years, the devoted wife of Mark Antony.

Further examination by experts revealed even more remarkable elements. The painting itself, on a finely-ground surface of gray slate rock was determined to be a supremely crafted example of the lost art of encaustic painting, employed by the ancient Greeks and Romans.

The artists of Caesar's time mixed powdered pigments in into a heated mixture of tree-resin and wax. The hot, mixed encaustic paint was skillfully applied to the slate tablets with a brass spatula. When the painting was completed, the entire surface was melded into a smooth finish by passing red-hot iron bars or braziers full of glowing embers close to the painting's surface.

But where could the clearly ancient painting have come from? Certainly, the artist would have been one of the best of his time, and there is a relatively short era of about 250 years during which the process of encaustic painting was developed and refined. It would necessarily been after the time of Cleopatra since it depicted her death by suicide. This leaves a very narrow time period of perhaps 50 years before the technique of encaustic was lost to history.

It is necessary to recall the circumstances of Cleopatra's death. The Emperor Octavian, Julius Caesar's nephew, had come with Roman imperial forces to wage war on Marc Antony and Cleopatra, and defeated the Egyptian forces. Marc Antony, returning from battle was told (incorrectly) that Cleopatra had already been killed.

Antony then fell on his sword, to commit suicide. Cleopatra, hearing this, rushed to him, and he died in her arms. Cleopatra, who had lived in Rome with Julius Caesar knew of the Roman custom of displaying their prisoners from vanquished nations in their victory parades. Royal prisoners were marched with chains on their wrists and ankles and led through the streets of Rome. The thought was unbearable to Cleopatra, and she devised a way to commit suicide, tricking the Roman guards that Octavian had charged with watching her.

Although the accounts vary, the story believed by Octavian was that an Egyptian servant brought Cleopatra a basket of figs, inside which a poisonous serpent was hidden. Cleopatra, with her two faithful attendants, arrayed herself in her finest clothes and jewelry, wearing a crown and ornaments of royalty.

She then ate some figs, reaching into the basket until bitten by the asp. Her attendants arranged her on her deathbed and then followed her example. Octavian himself is said to have seen the barely perceptible bite marks on her arm and the serpent's track marks in the sand outside the temple building.

Octavian was furious, having been tricked, and having lost his opportunity to display Cleopatra in chains in his triumphal parade. Later, back in Rome he commissioned an artist, most likely the Greek, Timomachus, to paint a picture of Cleopatra as she committed suicide. (Timomachus had also painted Cleopatra previously when she toured Greece with Marc Antony.)

Octavian then displayed the picture on a cart, which was then drawn through the streets in his victory parade. It created a sensation and was viewed by thousands. Later Octavian put the painting on public display in the temple of Saturn in Rome as a votive offering.

Years passed and the painting was handed down from emperor to emperor. One hundred and sixty years later, the Emperor Hadrian had an extravagant, palatial villa built outside of Rome at Tivoli. He furnished it lavishly and decorated it with fabulous works of art. The painting was evidently part of his vast collection.

At some point in time, likely years after Hadrian's death, it was carefully packed in a crate and hidden in a cellar, probably for safekeeping in times of war, invasion or the barbarian pillages that occurred in later years.

There it lay, forgotten and hidden for centuries until its re-discovery in 1818.

ANTIQUE PAINTING OF CLEOPATRA

Several unique elements of the painting attest to its authenticity and ancient origins. Cleopatra is depicted as the Macedonian that she actually was. Cleopatra was a direct descendant of Ptolemy I, who was both the boyhood friend of Alexander the Great and a general of Alexander's forces. He was given charge of Egypt by Alexander and installed himself as the new ruler of Egypt. Thirteen generations of Ptolemies ruled Egypt. Cleopatra VII was the last of her generation, and the last Pharaoh of Egypt.

Cleopatra, in the highly detailed painting is pictured as having dark blond or auburn hair and deep blue eyes. Alexander the Great, who was ethnically Macedonian, (not genetically related to the coastal Greeks that he conquered) was also blond-haired and blue-eyed. Many Macedonians even today still have the genetic characteristics with the prevalence of recessive genes that produce fair skin and light eye coloration. That fact that Cleopatra was not Egyptian, but a descendant of Macedonian royalty, may be difficult for many to accept, but it is nonetheless true.

The dynasty founded by Ptolemy was essentially comprised of Macedonian/Greek colonialists. (The names "Cleopatra" and "Ptolemy" are also Macedonian.)

Cleopatra's hair was depicted including individual strands, and is arranged in elaborate braids sprinkled with gold dust. This is in complete accordance with the marble sculptures of Cleopatra from Caesar's Rome.

Another very intriguing and significant element is the design of the crown and jewelry that Cleopatra wears. The crown is not Egyptian in character at all, rather it is nearly identical to the Macedonian crowns imprinted on coins minted by Ptolemy V and Ptolemy VIII. (The armband is strikingly similar to one worn by the wife of Heinrich Schliemann, who had excavated it from the ruins of Troy, which he discovered in 1865, years after the painting was found in 1818.)

The painting, after its discovery, first passed through the hands of a few owners, at one time even having been pawned. It

was later purchased by the Barron de Benneval (French) residing in Sorrento, Italy in 1860, who exhibited it in Paris, London, Munich and Rome. Two engravings after the painting enable us to determine the details as well as concise and written descriptions by eyewitnesses during the mid 1800s.

Cleopatra is shown to be quite beautiful, as the ancient Roman and Greek sources of Dio Cassius, and Appian have attested. (Recently there have been statements based on the image of Cleopatra on coins that are contradictory to this. It is more likely, however, that the coins were simply clumsily re-worked images of her father, Ptolemy XII.)

The Greek and Roman busts of Cleopatra show a woman with symmetrical features and smooth skin. There is a moderate bridge to the nose and slightly flared nostrils, but nothing that would be considered out of proportion or the least bit unsightly.

At present the whereabouts of the painting appear to be unknown to the general public. Its last recorded location was with the Barron de Benneval in Sorrento. It is likely that in the chaos of wars in the early 20th century, the painting was either hidden for safekeeping, lost in bombing raids or pillaged by invaders.

As of date of the preparation of this reproduction, efforts are underway to locate this great treasure once again.

ANTIQUE PAINTING OF CLEOPATRA

TO THE

BARON DE BENNEVAL

OF SORRENTO

ITALY

THIS BOOK IS RESPECTFULLY

INSCRIBED

BY HIS FRIEND

JOHN SARTAIN

OF PHILADELPHIA

U. S. A.

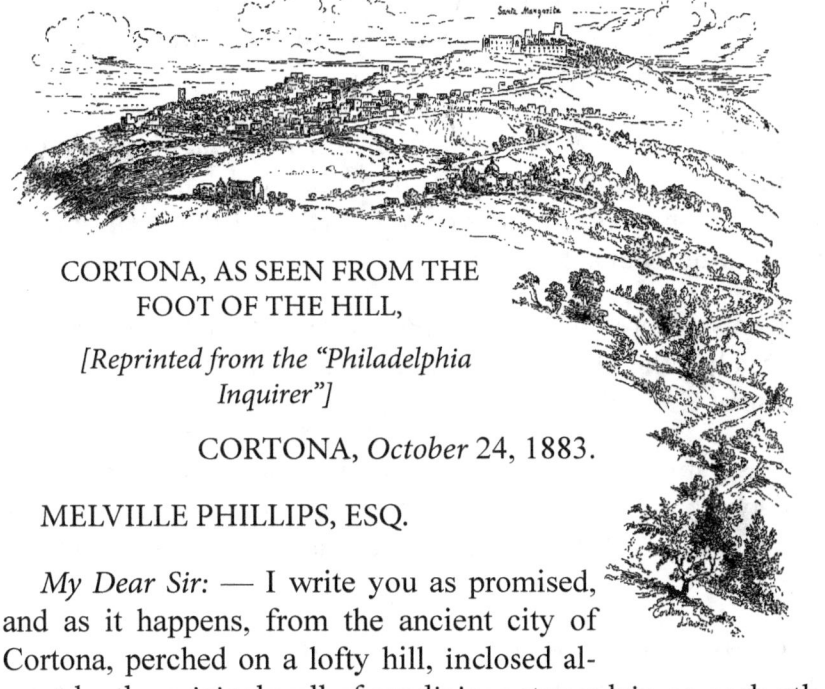

CORTONA, AS SEEN FROM THE FOOT OF THE HILL,

[Reprinted from the "Philadelphia Inquirer"]

CORTONA, *October* 24, 1883.

MELVILLE PHILLIPS, ESQ.

My Dear Sir: — I write you as promised, and as it happens, from the ancient city of Cortona, perched on a lofty hill, inclosed almost by the original wall of prodigious stones lain on each other in courses without cement, built by the Etrurians. From this commanding eminence we overlook, as from

> "An eagle's nest upon the crest
> Of purple Appenine,"

Lake Thrasymene and the comparatively level ground where Hannibal and his Carthaginians vanquished the hardy Romans. The small stream that flows into the lake acquired its name of Sanguinetta from this battle.

This place is exceedingly interesting on many accounts besides being one of the twelve confederated cities of ancient Etruria, you will remember that it was the birthplace of the celebrated artist, Peter Berretini, better known as Pietro da Cortona, and this mention leads me naturally to the business that brought me here,

the examination of an ancient picture in encaustic preserved in the Museum. It is the head and bust of a young female, her face viewed nearly in front, her right breast bare, and the left partially covered with drapery.

Her head is crowned with a wreath, which appears to be of laurel, but it is only faintly seen amidst her dark hair. Her left arm supports a lyre, but there is only a portion of this seen because the picture is but a fragment.

It was the presence of this musical instrument that caused her to be called the Muse Polyhymnia, and the work is known as the "Muse of Cortona."

It is painted in encaustic on oriental slate, and is one of the only two known pictures of the kind called by the ancients *tablet* pictures, as distinguished from mural works — painted on walls.

Of course there has been the usual discussion as to whether this painting is really antique, for there are always people of that peculiar propensity whose chief pleasure and amusement consist in throwing doubt on nearly everything of the past, no matter how well established by proof.

But even these place it in the epoch of the great artists of the Renaissance. The general decision of the archæologists, however, is in favor of its antiquity.

There is, besides, a small work in encaustic on slate in the Pinacothek of Munich, representing a dance of nymphs and satyrs, but it is only a fragment of little account, decorative in its character, and apparently part of a border. It was bought by King Ludwig I, of Bavaria, from an antiquary of Florence.

The Louvre also has three encaustic tiles, very rudely painted with portraits of the family of Pollius Soter, Archon of Thebes in the time of Hadrian, but like the Munich fragment, are of very

little consequence; and the same is true of a piece, in the British Museum, of half a human face.

The other more important picture is at Sorrento, in the possession of the Baron de Benneval, and represents Cleopatra receiving her death from the bite of an asp. This, like the Muse, is in encaustic and on oriental slate.

Both were discovered beneath the present surface of the earth; one near Centoja, between Chiusi and Montepulciano, in 1732, and the other amid the ruins of Hadrian's Villa near Rome, in 1818. The latter was found in sixteen fragments but is complete. The Muse was in one piece but is obviously only a part of a picture.

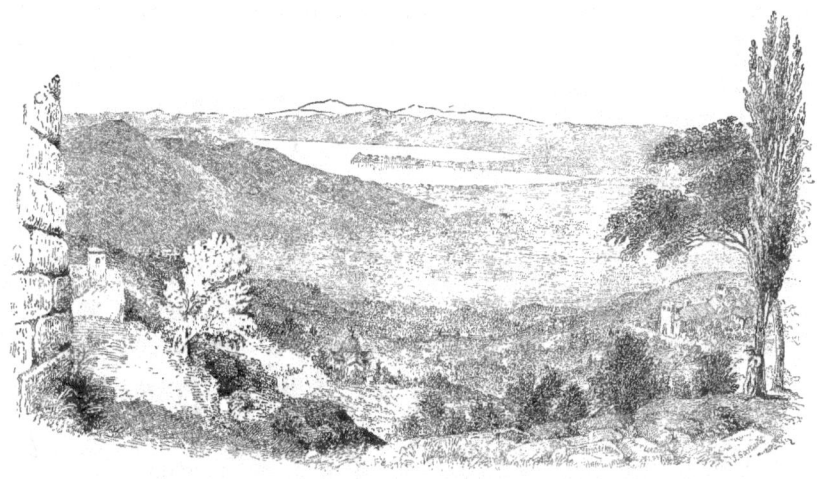

LAKE THRASYMENE, AS SEEN FROM THE HEIGHTS OF CORTONA.

The discovery of the muse of Cortona was accidental, and happened thus:

A farmer, while plowing in a field about three miles distant from the city, turned up a piece of slate, which, in examination, appeared to have a picture upon it, and on a more thorough cleaning he discovered what he considered a representation of

the Virgin Mary, so he placed it on a wall of his dwelling, and reverently fixed a taper in front of it, which he kept lighted. After a time his wife became very ill, and growing worse, a priest arrived to administer to the dying woman.

On seeing the picture, he inquired why the heathen thing was kept there. The man replied by explaining what he understood it to represent. The priest said it was nothing but a vile Pagan picture, and that he had better throw it away.

The farmer decided instead to put her in what he called Purgatory, by fitting her as a door to his oven. The picture was rescued from this barbarous treatment in 1735, by the Chevalier Tommaso Tommasi, proprietor of the domain, and it remained in his family until 1851, when Madame Louise Bartolotti Tommasi presented it to the Tuscan Academy of Cortona, which has placed it in its Museum.

The measurement of the picture is 38½ centimetres high, and 33 wide, representing the figure about two-thirds the size of nature. I cannot see that it has suffered any deterioration through its exposure to the heat of the oven, and this is probably owing to the fact that the ordeal of fire is one of the processes incident to its original production. But to ensure such objects from the risk of final loss, there needs must be the protection of some governmental depository, and such this interesting object has fortunately found.

The other example of ancient tablet painting is one of greater importance, and is preserved in the Villa of the Baron de Benneval at the Piano di Sorrento. This also is in good hands, but it too ought to find a permanent resting-place in some national collection, where it should be forever safe. It represents Cleopatra receiving her death from the bite of an asp, and of course it cannot be claimed that it is a portrait from life, as it was obviously painted subsequent to her tragic end.

ANTIQUE PAINTING OF CLEOPATRA

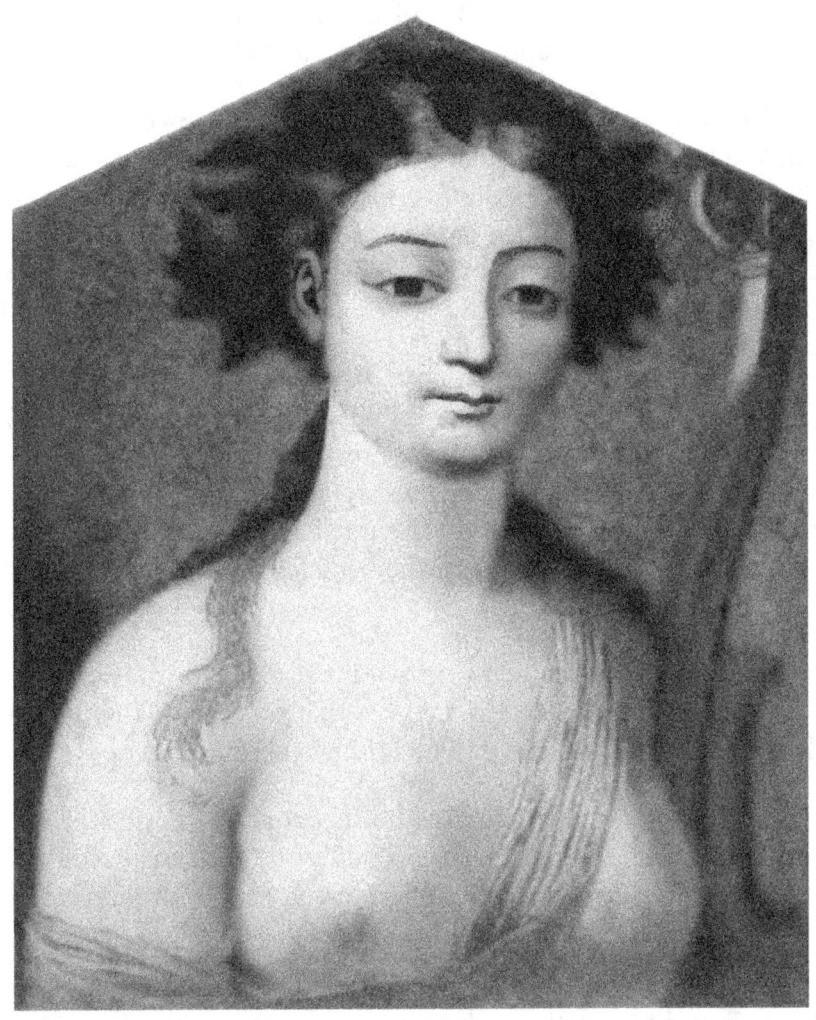

THE MUSE OF CORTONA, ON STEEL, AFTER THE ORIGINAL PICTURE AT CORTONA,

THE MUSE OF CORTONA

DISCOVERED BY A FARMER WHILE PLOWING IN A FIELD NEAR CORTONA

It was discovered by Micheli, the well-known antiquary, under the cella of the temple of Serapis, at Hadrian's Villa. Of the former picture, nothing is even surmised as to its origin, except that it is evidently Greek, but of the latter there exist data that furnish a reasonable approach to a connected history.

When found it was in sixteen fragments, which on being laid together showed that scarcely any part was missing. The disjointed pieces were taken to Florence, and submitted to the critical examination of the eminent advocate, Giov. Batt. Tannucci, of the Royal Academy of Pisa, who wrote an elaborate report on the subject, showing how profoundly he was impressed with the value of the discovery.

This report was printed in the "Autologia di Firenze," vol. 7. In August, 1822, the Marquis Cosimo Ridolfi, the distinguished scientist and chemist, assisted by Targiani Tozzetti, submitted the material of its composition to chemical analysis, and in that way arrived at exact knowledge of the vehicles employed along with the coloring pigments.

These proved to be two-thirds resin and one-third wax. These experiments are detailed in a report that was also printed in the "Autologia," in 1822, and of which I have obtained a copy.

The original manuscripts of both reports are deposited with the public archives of Florence. Finally the broken pieces were fitted together and united in a bed of cement. Both pictures are on oriental slate of a grayish tint.

The history of Cleopatra since its discovery is briefly this. Dr. Micheli and his brother, who were associated in the ownership, endeavored to secure a safe and permanent repository for their treasure in the famous Florentine Museum through a sale to the Grand Duke of Tuscany, but the large price demanded was refused, at a time so little removed from the political convulsions and great wars of the first French Empire, the finances of the

ANTIQUE PAINTING OF CLEOPATRA

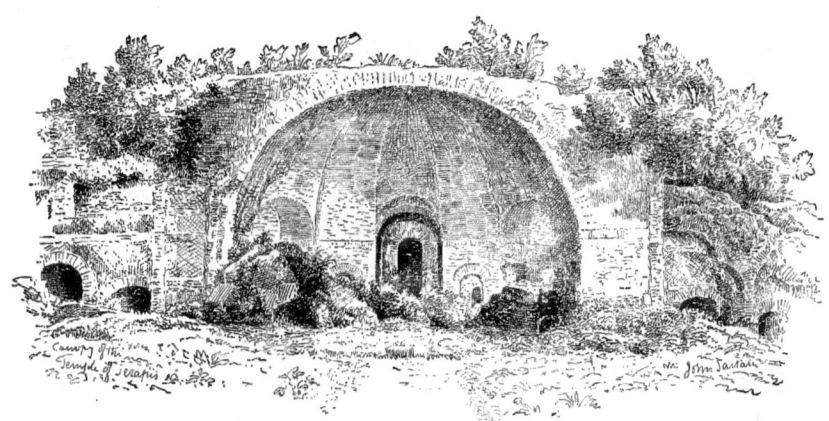

CANOPY OF THE TEMPLE OF SERAPIS, HADRIAN'S VILLA

Duchy requiring yet many years of economy for their re-establishment. Some years later, the business of the Micheli brothers falling into a decline, they realized funds by pledging the picture with some Jews, and soon after both died.

The charges went on increasing with time, and the heirs finding themselves unable to redeem it, sold it to an acquaintance of the Baron de Benneval, subject to these accumulated charges, and he rescued it from the hands of the usurers at serious sacrifice. Subsequently the new owner also found he could not afford to keep it, and the present owner purchased it from him in the year 1860.

Since that date, the picture has been exhibited in London, Paris, Munich and Rome. At Munich, M. Plater, the well-known restorer of King Ludwig's collection of Greek and Etruscan vases purchased from the Prince of Casino, being very enthusiastic over the picture, undertook to place it on an underbed of a peculiar cement, which has rendered it so secure that since then it can be transported from place to place without risk.

In 1869 the Emperor Louis Napoleon made an offer to purchase, which was reluctantly agreed to, and the picture was transported to Paris with a view to the fulfilment of the arrangement;

but the war with Germany began, and just on the arrival of the picture in Paris there occurred the battle of Forbach, which caused hesitation as to risking its delivery.

During the German siege of Paris and the Commune following, the painting was under the protection of the Prince Czartoryski, and after the liberation of the city the picture was returned to Sorrento, where it has remained ever since. I have now only to relate what appears to have been the origin of the picture, and how it came to the place where it was found.

Augustus Cæsar being deprived of the presence of Cleopatra in person to grace his triumph (the Queen having evaded that humiliating exposure by suicide), decided on having at least a representation of her.

It is on record that a picture was painted for this purpose, and was borne on a car or litter near his own, along with other objects of Egyptian interest and of great value, taken from the monument in which she died; and since it was thus carried on the attendant car, it was obviously a *tablet* picture.

After it had answered this use, he placed it as an offering in the temple of Saturn at Rome. There can be little doubt that this is the Sorrento picture.

This painting has given rise to voluminous literary research, and some writers claim that it is the work of the famous Byzantine artist, Timomakos, who was the author of two pictures purchased by Julius Cæsar at the enormous price of eighty talents ($350,000), which he presented as an offering to the temple of Venus Genetrix. One of these was of "Medea," the other "Ajax," the former one unfinished.

It is also asserted that this artist saw Cleopatra when she visited Greece, summoned thither by Mark Anthony, and Anthon places him as contemporary with Cæsar and the Egyptian Queen, although some authorities locate him at an earlier period.

Be this as it may, by whomsoever done, it was doubtless paint-

ANTIQUE PAINTING OF CLEOPATRA

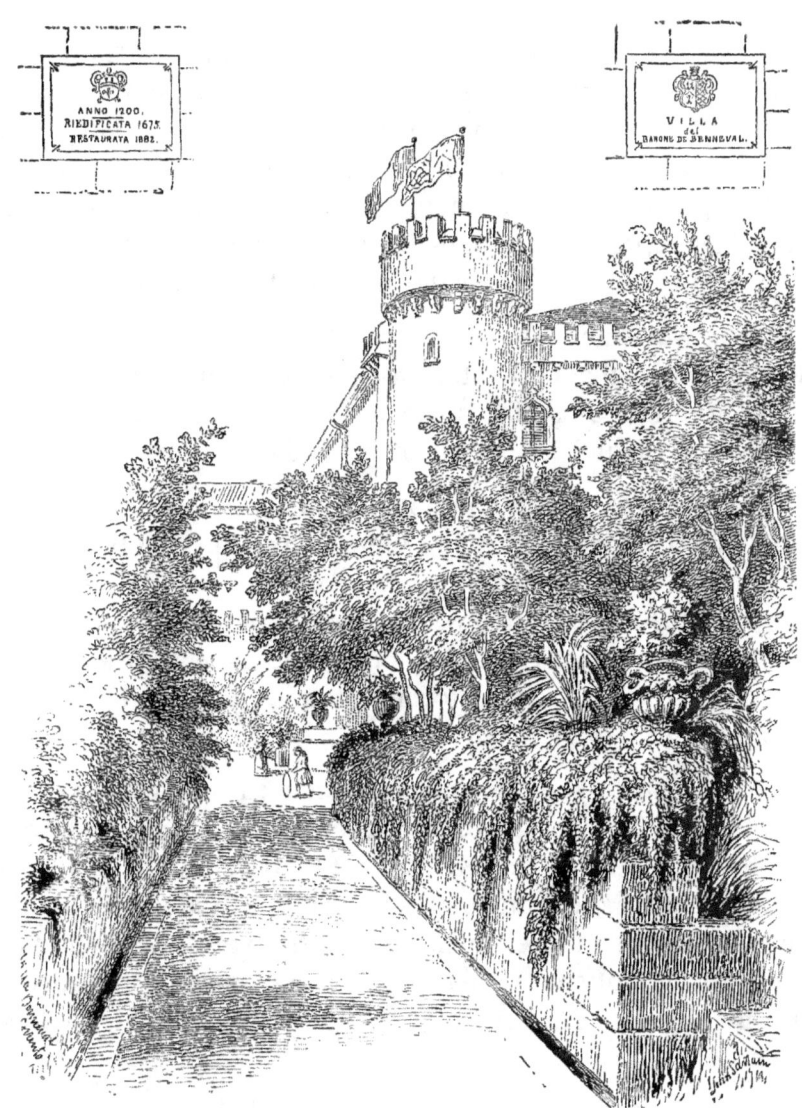

VILLA BENNEVAL, PIANO DI SORRENTO

ed about twenty-nine years before the Christian era — assuming it to be the identical picture known to have been produced for the use named.

Some hundred and forty years later, the Emperor Hadrian removed from Rome a large amount of the choicest art treasures of the city to enrich and adorn the vast villa he had caused to be built near Tivoli (the ancient Tibur), and no doubt the Sorrento Cleopatra picture was among the objects thus gathered, and it found an appropriate resting-place in the temple of the Egyptian god Serapis, since that was the locality of its discovery.

It is well known how many of the most beautiful and celebrated statues that enrich the national museums of Europe were dug out of the ruins of this wonderful villa, as, for example, the "Venus de Medici," the "Antinous," and other important works.

The Muse of Cortona, although a small picture, is nearly life-size, but the Cleopatra is full life-size, though like the Muse it is only half length, including, however, more of the figure. The famous Queen is depicted with the crown of the Ptolomys on her head, splendid jewels around her neck and in her ears, and on her arms are bracelets similar to those found by Schliemann in the tomb of Helen of Troy.

A red mantle gathered in a knot on each shoulder covers her right breast, but the left is exposed to the bite of the Asp, or rather the Naja, a small serpent native to Africa. Three small scars indicate where the reptile has already bitten, and we see that it is in the act of again inserting its fangs. The expression of grief and pain is well rendered in her face, her tongue is pressed forward against the slightly opened teeth, the upper lip lifted, the lower lip droops.

The pupils of the eyes are raised until half concealed by the upper lids, the escaping tears, the nose drawn and narrowed above the nostrils, all these express forcibly the mental and bodily anguish of the Queen. The rich attire in which the picture represents her, is in accordance with the facts of her death, for it is

known that she caused herself to be arrayed in royal robes, and every personal adornment, in order to meet her end right royally, and thus she was found after death.

The Greeks set great value on the works of their best painters and enormous prices are recorded as having been paid for them, as you know.

A picture painted by Apelles for the city of Cos, of Venus Anadyomene rising from the sea, was received by Augustus Cæsar three hundred years later as an equivalent for one hundred thousand dollars, notwithstanding an irreparable injury to the lower portion of the figure.

The paintings by which Zeuxis, Apelles, Protogenes, Apollodorus, and the rest of the celebrated Greek artists achieved their lofty reputation, were *tablet* pictures, wrought in encaustic by the aid of a very high degree of heat, a method lost since the time of the ancients.

The process of production of these Greek tablet pictures is described by Pliny as far as he was acquainted with it, but in his day the art had already so far passed into disuse as to have become nearly obsolete.

Taste for pictures among the Romans had declined rapidly and he laments that they no longer cared for them; they were out of fashion.

The pictures found on the walls of Pompeii, Herculaneum, and elsewhere, are for the most part of a merely decorative character, rising occasionally, however, into a superior manner, such as may be seen in the example acquired not long since by the British Museum from my friend, Mr. George Richmond, R.A., of London.

Works in sculpture, it is true, were still in demand, and the style of the day may be judged by the labors of the artist's chisel on the Arch of Titus at rome. But so rapid was the loss of skill, even in sculpture, that the Titus was despoiled of a portion of

its adornments to enrich that of Constantine, on which edifice they contrast strikingly with the puerile productions of the later period.

As I said, much has been written concerning this Sorrento picture. In 1879 there was published in Naples a pamphlet about it written by Emmanuele Berni, Conte Canani; and in 1881, the "Nouveau Temps" of St. Petersburg, contained a long article in the Russian language by Michael Iwanoff, a correspondent of that journal, who had seen and studied the work.

Another review of the picture appeared in the "Revista Settimanale" by a high authority in matters of this nature, and Houssaye speaks of it in an article upon the "Ancient Paintings of the Museum of the Museum of Naples," published in the "Revue des Deux Mondes," in 1874, and regrets that it had not been purchased for one of the great museums of Europe.

At first he attributed it to Leonardo da Vinci, an authorship disproved by its process of production, for in his time, the ancient art of painting in encaustic still remained a lost art. But this opinion expresses the famous critic's high appreciation of the artistic excellence of the work.

The most important of all the papers that have appeared was published at Augsburg, in the "Allgemeine Zeitung," in August 1882, in the supplements to the numbers 227, 228, 229 and 230. It is from the pen of Dr. R. Schoener, and is a most elaborate, learned and exhaustive treatise, leaving, it would seem nothing more that could be said on the subject.

I have with me copies of all these essays, and if a book were made of a portion of them, in a manner to avoid repetition, it would constitute an interesting and most instructive work. And such a book I propose to myself to make as soon as I arrive home, illustrated with sketched representations of the places where the pictures are now, and where the Cleopatra was found. Also with faithful finished engravings on steel of both the Muse of Cortona and the Cleopatra.

There now remains but little more to detain me here beyond making a couple of sketches, one of the famous Lake Thrasymene — "reedy Thrasymene," as Macaulay names it — with the city of Castiglione del Lago on the extreme end of a tongue of land protruded far out into the lake.

This will be taken "from where Cortona lifts to heaven her diadem of towers." The other will be of the city of Cortona as seen from the foot of the hill on which she stands.

Then I leave for dear Florence, on my way home, and on my arrival will submit to your critical inspection the materials I have collected for my projected book.

 Ever yours truly,

 JOHN SARTAIN.

ANTIQUE PAINTING OF CLEOPATRA

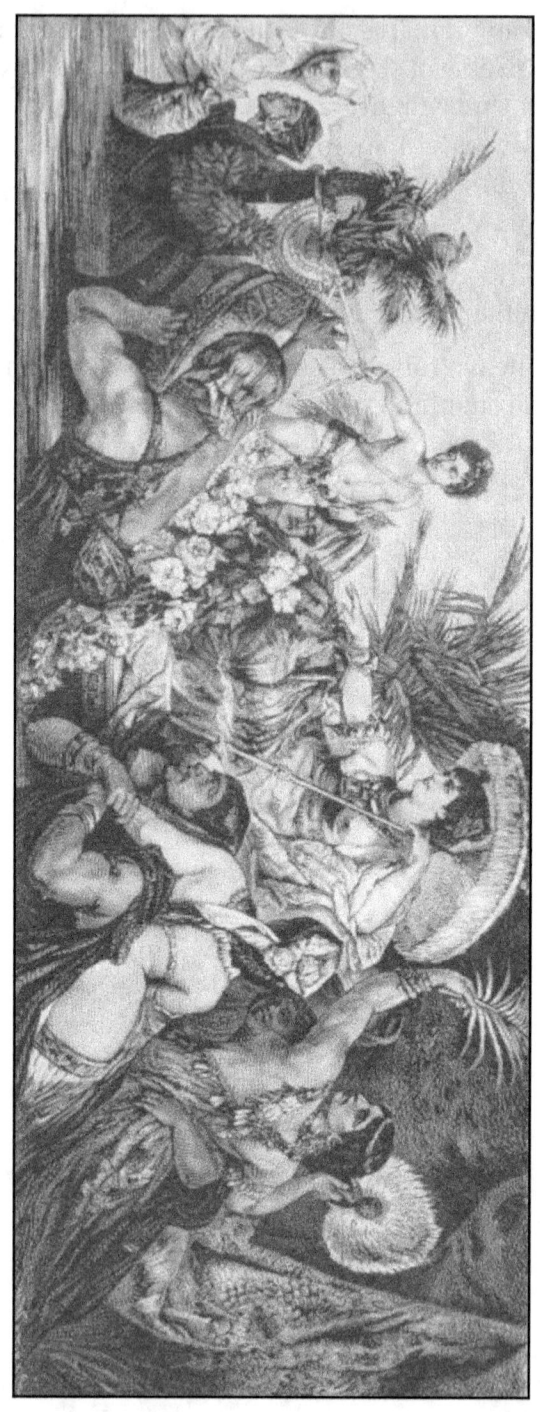

CLEOPATRA ON THE CYDNUS, ON HER WAY TO MEET M. ANTHONY. (AFTER MACKART).

ANTIQUE PAINTING OF CLEOPATRA

[From the "Autologia," vol. 7, No. 20, August, 1822, Florence, Tuscany.]

THE FINE ARTS.

LETTER OF M. LE MARQUIS COSIMO RIDOLFI TO THE PROFESSOR PETRINI, CONTAINING A REPORT OF THE RESULTS OF A CHEMICAL EXAMINATION OF THE MATERIALS USED IN AN ANTIQUE PAINTING IN ENCAUSTIC, REPRESENTING CLEOPATRA.

I address myself to you, Monsieur le Professeur, because you are so much occupied with the study of the colors employed in the painting of antiquity, and I feel satisfied that you will be interested in the work that I have just completed in an endeavor to discover what colors and mastics were used in a picture as precious as it is ancient, representing Cleopatra wounded by the asp. It is life size and more than half length.

This valuable work was in the possession of Doctor Luigi Micheli, a learned connoisseur and intelligent collector of objects allied to the fine arts, and he did me the honor of confiding to me the chemical examination of this remarkable picture, which, besides its value for correctness of design and refinement of expression, and also its richness of coloring — possesses such a singular impastation as to increase still more the interest that it is naturally calculated to awaken.

The painting is executed upon a slate, grayish and compact. Five colors seem to have been used, one green, two reds, one yellow and one white, readily distinguishable to artists doubtless, who classify and mix them in tints, but less so to science. Therefore I ask your indulgence to excuse my expressions if they are not those usually employed in the profession.

One observes that no indication appears of the use of a brush. The layer of colors on the surface of the slate is very thin, and all the separate parts are so well united as to resemble enamel, possessing its brilliancy and almost its glassy effect.

Between the general surface of the picture and the outlines of the face, a difference of thickness is perceptible, and the same difference occurs between the drapery and the flesh, and also between this and the ornaments.

I note these details not to attempt an explanation, but rather to excite a desire for deeper investigation in those to whom it may be as interesting as to myself.

An impastation of green earth and of carbonate of copper constitutes the green color used in the entire background, which represents a curtain — the tritoxide of iron furnished the red color of the mantle, and red oxide of lead its shadows; yellow ochre was employed to imitate the gold of the jewels, and white lime has given the lights.

The substance used in painting the flesh has not been analyzed, because the owner was unwilling to have so important a part injured by scraping.

The vehicle with which the colors were combined, I found to be soluble in ether, and after the evaporation of the solvent it remains of a yellowish color, giving out an odor resembling that of myrrh; soluble in alcohol, but insoluble in water.

It dims the alcoholic solution, which, when burned, exhales smoke like that from the combustion of wax, and arrives at a state of fusion only at a temperature higher than that required to melt the wax. Hence inferred that there was some kind of resin mixed with the wax.

I next proceeded by a different method to separate the substances by means of heat. I dissolved the whole in caustic ammonia by the application of heat, and then, by adding a little muriatic acid, I obtained a flaky white precipitate, which I washed with

care and then dried. The substance then was not wholly soluble in alcohol, but only in part, the resin leaving with the alcohol and the wax remaining, the former reappearing by evaporation presented all the characteristics of mastic. The final result was that I found by weight one part wax and two parts resin.

I now dropped them, in the proportions just stated, into pure oil of naphtha and made a rather dense varnish. To this I added tritoxide of iron, and this paint I spread with a brush on a piece of slate. It took at once, but it had no brilliancy and showed the marks of the brush.

I then left the slate in a horizontal position and brought a red-hot iron iron near to it. A fusion was soon produced, the varnish became brilliant and the brush marks disappeared. I now crossed this spread of color with lines of other colors, prepared in the same manner as already described, and again produced a fusion by means of heat as before.

I found that the colors were not mixed, that the layers were on different levels, and that those that had undergone the two fusions had lost some of their brilliancy.

I now repeated the experiment, but after the same manner as before, except that I subjected the work to only one general fusion. I first spread a flat background of red; on this I drew two parallel lines, one green and the other yellow, these I crossed at right-angles by two other lines, one white and one black. After the fusion and the gradual cooling, every part was transparent and clear.

On another piece of slate I drew two parallel lines of color a short distance apart, one red the other green, and while they were yet fresh I dipped a brush in oil of naphtha and drew it down in a way to blend the two colors. The fusion that followed die not alter, but only improved the effect.

I do not claim, Monsieur le Professeur, that I have discovered anything new, and I imagine that I hear you cite Pliny among the ancients, and Fabbroni among the moderns, who have de-

scribed the process of painting in encaustic as practiced by the eminent Grecian artists prior to the decadence. But I do believe that my analysis proves the picture of Cleopatra to be an ancient production in encaustic, done before the decadence, and that it is a precious relic, wonderfully well preserved. Since the renaissance of art, and since the invention of oil painting, no mention is to be met with of any one having known or attempted to work in encaustic. It has been universally conceded to have been one of the lost arts.

ANTIQUE PAINTING OF CLEOPATRA

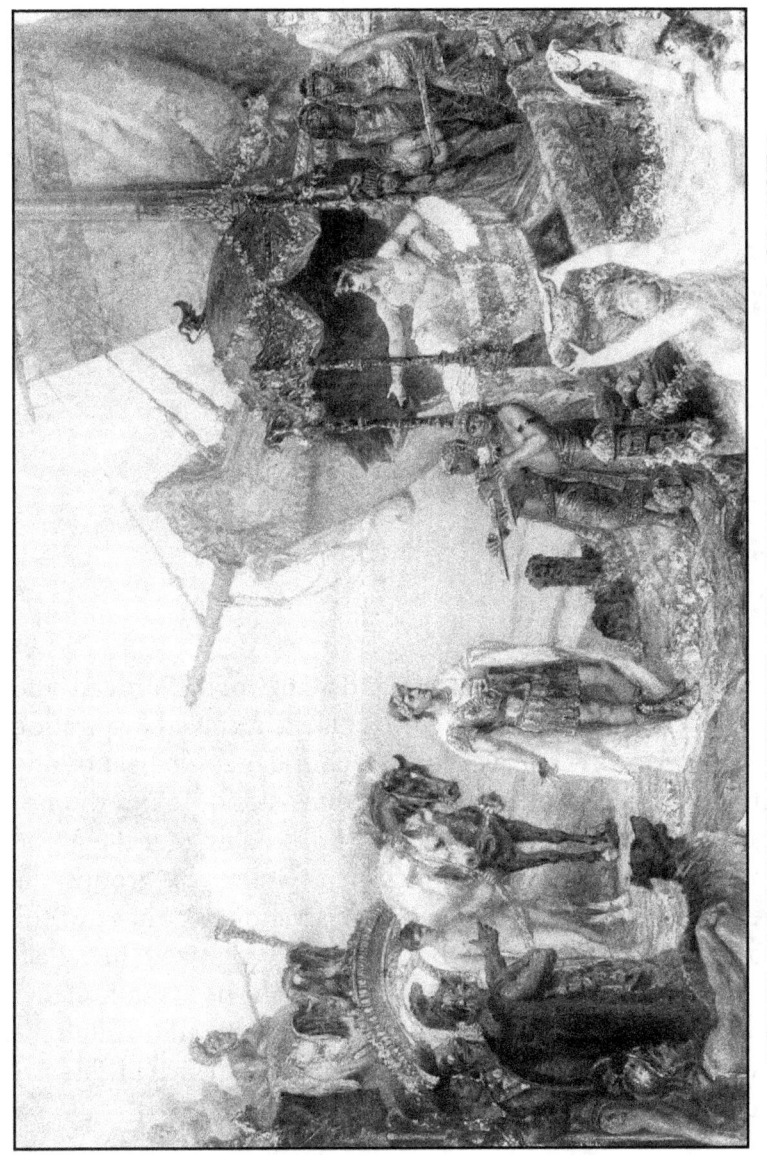

FIRST MEETING OF ANTHONY AND CLEOPATRA, A PHOTO-GRAVURE. (AFTER G. WEITHEIMER).

ANTIQUE PAINTING OF CLEOPATRA

[From the Supplements to the "Allgemeine Zeitung," Augsburg, 1882, Nos. 227, 288, 229 and 230.]

AN INQUIRY INTO THE ART OF PAINTING ENCAUSTIC AS PRACTICED BY THE ANCIENTS, AND ON THE ANTIQUE PICTURE OF CLEOPATRA IN THE POSSESSION OF THE BARON DE BENNEVAL, AT SORRENTO.

BY D. R. SCHOENER.

He who has surveyed the Logge and Stanze of the Vatican, and considered whence the divine Raffaelle received inspiration for the creation of this overflowing abundance of beauty and graceful ornamentation; he who has once stood before the noble forms and groups of the Aldobrandini wedding, or the grand composition of the Alexander mosaic, the Greek vase groups, the Pompeian and Herculaneum mural decorations — those of the baths of Titus and the Roman tombs — has recognized the reflection of a greater epoch of the art of painting; he needs not further evidence of the greatness of the loss we have suffered through the destruction of by far the best examples of art. Especial ill-fate has attended them.

Many, no doubt, fell a sacrifice to the perishable nature of the materials, while those which have survived, preserved through peculiarly favorable circumstances from the destructive influ-

ences of the atmosphere and from accidents, like the paintings in the cities buried by the ashes of Vesuvius, belong to a time of decay, and with very few exceptions to an inferior school of art.

It is, therefore, not surprising, that for a long time an opinion prevailed as unfavorable as erroneous concerning the development and value of ancient painting.

It is also just as little to be wondered at that obscurity and contradiction have obtained about the methods of the painters of antiquity, and this notwithstanding the apparently thorough and abundant information left by ancient authors concerning the technique of their artists.

To-day we know that the Egyptians and Orientals as well as the Greeks and Romans, painted upon stone, wood, clay, stucco and parchment, the last upon linen also; that they painted upon the walls al-fresco as well as al-secco; that in the higher art tablet pictures painted in encaustic were common; we know exactly what colors and vehicles they used, how they prepared and applied them, what advances and changes in technique were made, and so forth.

PART OF THE IMPERIAL PALACE, HADRIAN'S VILLA

We intend — and in the sequel the reader will see why — to consider only one of the ancient modes of painting, that is the

encaustic. This we must necessarily do in a somewhat detailed manner, since the technical question, the already very extended discussion of which is not yet closed, stands in close connection with our subject.

In the statements of the old writers regarding encaustic painting — that is, painting with wax or resinous colors made permanent by the action of fire — we have to lament, not so much the scantiness of the particulars, as their lack of clearness. Vitruvius, and especially Pliny, often returned to the subject, but the repetition does not diminish the obscurity. The expressions used admit of different interpretations.

Neither Vitruvius nor Pliny was thoroughly acquainted with the technique of painting; both were mere compilers, reproducing the assertions of others without themselves well understanding them. Greater distinctness seemed to them needless, because their contemporaries were sure to comprehend.

ANOTHER PART OF THE IMPERIAL PALACE, HADRIAN'S VILLA

It has, therefore, required more time and more careful study of the remaining ancient paintings to understand the nature of encaustic as well as of the other methods used in antiquity. The well-preserved paintings of Egypt, those in the tombs of the

kings in the valley of Bab-el-Melook, at Thebes, for example, and in the Hypogäen of Beni-Hassan below Antinoe, show that already more than two thousand years before the Christian era the Egyptians had reached a high degree of perfection.

The colors employed by them have been described by Count Caylus, one of the first among moderns to occupy himself with the study of ancient art technique.

With the same aim Gmelin submitted mummy decorations to searching examination. We are indebted to the Tuscan expedition, conducted by Rosselini, for important results.

As Rosselini informs us, it was shown by Fabbroni's chemical analysis of some mummy painting, that the Egyptians understood encaustic, and used for it a mixture of wax and naphtha.

An analysis made by Professor Geyer, in Heidelberg, of a piece of painted stucco from a tomb at Bab-el-Melook, shows also with great probability that wax and resin were mixed with the colors. Rosselini brought to the Florentine Museum a female portrait executed upon a tablet of sycamore wood, which he regarded as Greek work and also as encaustic.

He was led to this opinion by the decision of Migliarini upon two or three portraits intended to cover the faces of mummies, which were formerly in the Salt collection, and afterwards bought by Charles X for the Louvre.

These were similarly executed and were pronounced by Migliarini to be painted in encaustic. Angelelli, one of the artists of the Tuscan expedition, collected samples of colors whose chemical analysis has given results which are very important for our subject, and to which we must beg even now to direct particular attention, although further on we shall have to speak of them more in detail.

ANTIQUE PAINTING OF CLEOPATRA

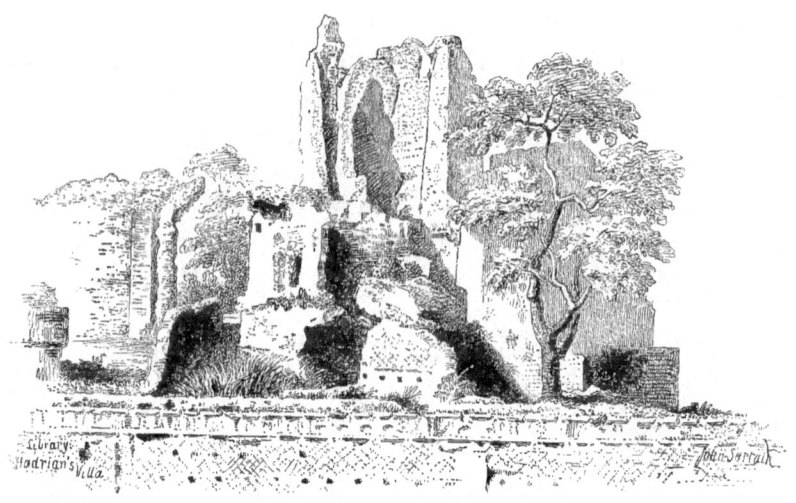

THE LIBRARY, HADRIAN'S VILLA

Among these Egyptian colors an especially well-preserved white Migliarini takes to be the parætonium of Vitruvius and Pliny, so called after the place where it was found near the city of the same name, the capital of the Lybian Nomos.

It is not lead white, which the Egyptians never used, but a very fine and white lime earth. According to Fabbroni the same white is used in the above-mentioned encaustic portrait. The yellow in Angelelli's color samples is iron ochre (the Latin ocria or sil), the best of which, according to Pliny, is found in Attica.

The red, of a beautiful tone, is tritoxide of iron. Vitruvius places the Egyptian next to the best, that of Sinope; Pliny asserts that the Egyptian and the African are the best for painters. The blue, of which Theophrastus mentions three qualities — the Egyptian, the Scythian, and the Cyprian — was invented in Egypt, Vitruvius says, and thence imported to Puteoli.

According to him it was prepared by burning a mixture of saltpetre, sand and chippings of copper. The eminent chemist, Sir Humphrey Davy, also analyzed a number of remains of ancient

color, and ascertained that the same colors were used in Athens and in Rome. He found in this same blue, which he regards as the Egyptian, fifteen parts of carbonate of soda, twenty parts of siliceous stone, and three parts filings of copper.

But since in nine ancient blue glasses of different origin, he always found cobalt instead of copper, he is of the opinion that Theophrastus confounded the cobalt with copper. The green of Egyptian painting was mostly a green earth, the best of which, according to Vitruvius, came from Smyrna, and was named after the discoverer Theodotion.

Jomard says that the green in the Egyptian pictures has suffered more than the other colors, and might often be confounded with the blue. Finally, the black of these pictures was an oxide of iron, like the red and yellow.

It is not necessary here to consider the question whether Egyptians were the instructors of the Greeks in encaustic painting as they were in so many other branches of knowledge. It suffices to know that encaustic was used very early by the Greeks.

Pliny, who — from ignorance, however — does not mention the Egyptian wax painting, ascribes the discovery of it to the Greeks. Since our knowledge of the technical management rests essentially upon his statements, we cannot leave unmentioned the principal points, which, on account of their want of clearness have been differently interpreted and often discussed. He says, "It is not certain who first hit upon the thought of painting with resinous colors and burning in the painting. Some are of the opinion that it is a discovery of Aristides, afterwards perfected by Praxiteles. But there are encaustic paintings considerably earlier, for example, by Polignotus, as well as by Nikanor and Archeselaus of Paros. Lysippus also wrote about one of his pictures in Ægina ('has burnt it in,' that is painted in encaustic) which he would certainly not have done, had not encaustic been already invented."

ANTIQUE PAINTING OF CLEOPATRA

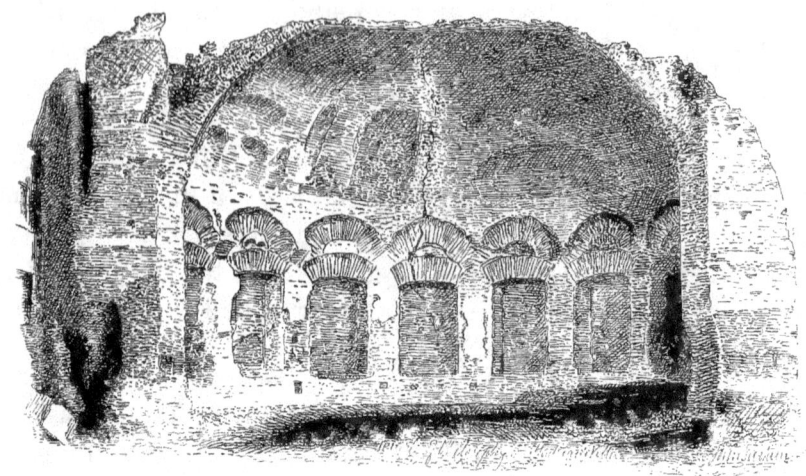

TEMPLE OF THE PHILOSOPHERS, HADRIAN'S VILLA

Pliny states further that Pamphilus also, the preceptor of Apelles, not only painted in encaustic himself, but gave instruction in it to Pausias of Sicyon the first distinguished artist in this method.

It is important for the understanding of the technical methods employed in encaustic, to note that the brush was not used in it, for Pliny divides painters into two classes, painters with the brush and painters in encaustic.

According to him both methods of painting were known already before the 94th Olympiad, 404 years before Christ, but the encaustic was the later of the two.

The first master who executed an important work with the brush was Apollodorus; in this method of painting Zeuxis won great fame in the fourth year of the 95th Olympiad, 397 years before Christ.

Other prominent practitioners of the art were Parrhasius, Timanthes, Eupompus, Aristides, Pamphilus, Apelles, Protogenes,

and Nicomachus. Beside those named above, the following were also reckoned as painters in encaustic: Euphranor, Nikias Timomachos, Aristolaus, and others.

But encaustic was more commonly employed after the time of Alexander the Great, since then the taste for tablet paintings increased, particularly for portraits, for which they were especially suited.

Pliny says expressly that they (portraits) were much less suitable for wall paintings. Although by the study of the mural decorations, traces of wax have often been found, there is another explanation as we shall see.

The difficulty begins where Pliny speaks of two different classes of encaustic painting. "It is notorious," he says, "that since ancient times two kinds of encaustic were practiced, until they began to paint ships with wax; and upon ivory with the *cestrum*;" that is in the painting stylus.

This third kind that came into use, consisted in melting the wax colors over the fire and using the brush, a kind of ship painting which resisted injury from either salt-water or winds.

Setting aside the different interpretations of this passage, and the criticisms upon it; our opinion is that the difference between the first two classes consisted in this, that one was a real painting with wax colors, the other simply an engraving upon ivory, that the brush was not used in either kind, but a stylus pointed at one end for incising the outlines, and broad at the other for laying on the colors.

Here we have to do only with the first class, the wax color painting. We will next consider how colors were used, and after that in what the method consisted.

The well-known statement of Pliny, that a number of the most distinguished Greek painters — he mentions Apelles, Aétion,

Melantheus, Licomachus — used only four colors, of course, cannot be taken literally. Without doubt their scale of colors comprised also mixtures of the four primary colors, white, yellow, red and black.

Sir Humphrey Davy is of opinion that the color scale of the ancients was not inferior in scope to that of the great painters of the sixteenth century.

They possessed vermilion, red arsenic, and red oxide of lead, different red earths, madder, yellow ochre from Attica, Achaia, Lydia, Gaul; Scythian and Cyprian copper blue, Lapis Lazuli, cobalt, copper green, brown ochre, charcoal and Chinese black.

For colors that are not suited to fresco painting but require a chalk ground, and can also be used in encaustic, Pliny enumerates purple, indigo, cæruleum (Egyptian blue?), white clay earth from Melos, arsenic yellow, appianum (a mixture of blue and vegetable yellow) and also lead white.

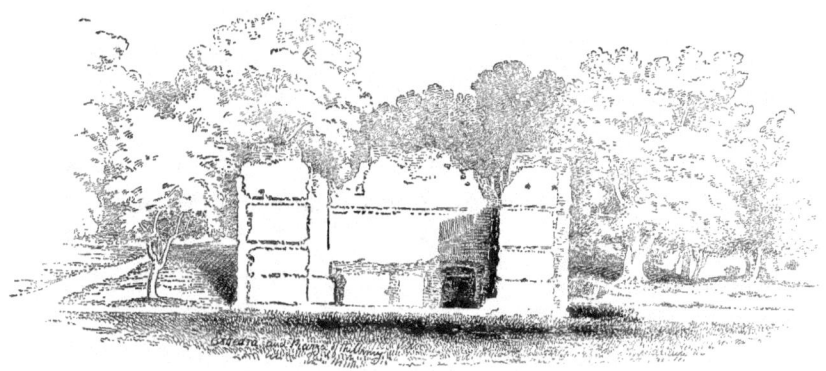

EXEDRA, AND PIAZZA OF THE ARMY, HADRIAN'S VILLA

The purple and the Egyptian or Alexandrian blue were also colors which the ancients possessed. Sir Humphrey Davy›s study of the colors found in pots among the ruins of the Baths of Titus, as also the paintings of the Baths themselves, and finally of the so-called Aldobrandini Marriage, has given the following re-

sults: Three kinds of red were used in the Baths of Titus: a bright red approaching orange, consisting of vermilion and red oxide of lead; a darker red which is iron ochre, and finally a purple red also of iron ochre.

The ochre was used especially in the shadows of the figures, the vermillion in the ornamentation of the border. The yellow was yellow ochre, sometimes mixed with oxide of lead and chalk, the blue — the light as well as the dark — a frit of soda and oxide of copper, which has almost the tone of ultramarine, and perhaps is the Alexandrian blue — cæruleum — sometimes mixed with carbonate of lime.

Three kinds of green are found: Veronese green earth, carbonate of copper alloyed with chalk, and green copper combination with blue copper frit.

The black was charcoal and the white was chalk or fine clay. In the Aldobrandini Marriage all the reds and yellows are ochre, the blue cæruleum, the brown a mixture of black and yellow ochre.

After the colors the vehicles of the ancient painters are soon mentioned. So far as we know oil was not used in painting, although they were acquainted with a varnish of wax and oil, which served for covering marble statues, as well as walls painted with vermilion.

For the preparation of the color they used glue, egg, and different tree resins or kinds of gum, so that one can speak of tempera and gouache painting among the ancients, but not of oil painting.

Numerous remains of ancient temples, dwelling places, tombs and so forth, show how universal was the practice of wall painting.

Yet it is easily understood that there were figure and scene paintings of a higher style of art, which were, as old representations show, either hung upon the walls or let into them.

Pliny declares that it was not the custom among the Greeks to paint the entire wall, that neither Protogenes nor Apelles painted the walls of their own rooms, and that the true fame of the painters was gained only by *tablet* pictures. For these the Greek artists preferred to use wooden tablets and those of larch wood were considered the best.

The wall painting of the ancients was, as is now determined, partly fresco and partly tempera painting. In Pompeii and Herculaneum both are extensively found.

According to Winckelmann, indeed a tablet of white wax was found in a room in Herculaneum among an artist's colors; nevertheless, as Chaptal and Sir Humphrey Davy have definitely proved for Pompeii, wax was not used for wall painting.

But this was the case according to Knixim's inquiries among the Egyptians, who as embalming proves, were acquainted with the preservative property of resin, and also used for wall painting a mixture of wax and resin in which the latter predominated. According to Knixim, it was cedar, cypress and pine resin, also copaiva balsam.

That wax was a customary ingredient in the colors of the Romans, is shown by their using the expression *ceræ* instead of the word colors. For encaustic some wax was probably mixed with the resin in order to make the mass more pliant and to flow more readily. The preparation was as follows:

The so-called Punic wax was cleansed and bleached by boiling it several times in sea-water with natrum, and afterwards exposing it to the air and sun. It was then mixed with the colors, and, as appears from a remark of Seneca, as many tones were made as they thought they would need. The colors so prepared were preserved in a dry condition in chests or boxes with many divisions, and such little chests which somewhat resembled our boxes of water colors, are seen in several antique representations.

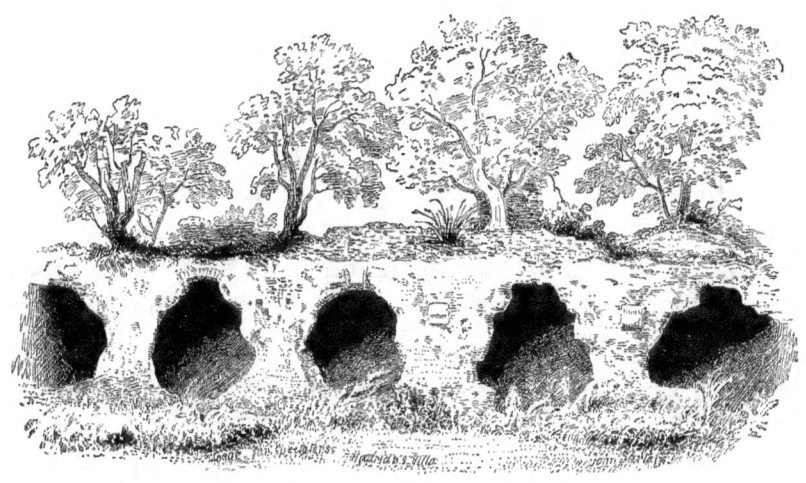

LOGGE FOR SPECTATORS, HADRIAN'S VILLA

In painting with wax colors they did not use the brush, as we have already seen, but the so-called *cestrum* or *verriculum* that is several times mentioned by Pliny.

This was pointed at one end, and at the other end a flat stylus, and could therefore — according to Donner — be also used as a spatula. That the name *verriculum*, concerning whose orthography and meaning there is a great difference of opinion, is not derived from *veru*, Donner has already proved.

For several reasons, whose enumeration does not belong here, we believe that the word is derived from *verrere*, and therefore originally means "that which removes;" and, indeed, in encaustic painting it served not only for laying on the colors, but also for removing them.

The technical method was most probably the following: After the painter had drawn the outlines of his picture with the sharp end of the metallic stylus, in the ground to be painted — which, perhaps, as Hirt supposes, was a thin layer of wax as upon writing tablets — he took the colors out of the box with the flat end of

the stylus, which had been heated, and laid them on. By repeated heating of the *cestrum*, these were spread, and after the finishing of the work, the whole was burnt in by means of a brazier of burning charcoal, and so fixed, and at the same time made glossy.

So thinks the Abbe Requeño. Hirt declares that later attempts done in this manner have been perfectly successful, and Grund says: "A picture painted in this manner has exactly the appearance of an oil painting, and in the workings of the hot stylus one fancies he sees the working of the oil color brush; the picture also appears as soft and strong in oils, and without needing varnish, because the colors remain the same during and after the work; also they absolutely cannot grow dark or suffer any other change."

C.A. Böttiger believes that in encaustic painting they employed neither brush nor stylus, but "used thin, already prepared and colored wax pastels or wax sticks, which, while at work, they melted at a brazier standing near, and so laid on the colors." Tommaselli is of the same opinion, and declares wax painting to be pastel painting. Wattenbach, on Plutarch›s authority, says: "The painters used a glowing rod, yet we cannot doubt the habitual use of the *cestrum*."

It should also be mentioned that the ancients frequently used the wax varnish, which served them for polishing their marble statues, for covering walls painted in tempera in order to give the colors richness and durability. Apelles used a varnish or glazing whose ingredients we do not know, but which was highly praised by Pliny.

How appropriate the method was, the wall paintings in Pompeii and Herculaneum, in the Baths of Titus, and the house of Germanicus on the Palatine, prove, which in part have preserved a gloss and a freshness of color which awaken surprise. Vitruvius, and Pliny also, say, "by means of brushes they spread over the picture a mixture of wax and oil which on the application of the charcoal brazier became warm and evenly spread; afterward the

picture was rubbed with a wax candle and linen cloths till it was highly polished."

When Vitruvius characterizes this method as kau=sij, it is clear that this has reference only to the heating of the varnish; that we have to do only with the waxing of the wall painting, and not with encaustic wall painting. According to Stieglitz this method has been tried in late times with success, and the Roman works in stucco and marble are polished to-day in a similar manner.

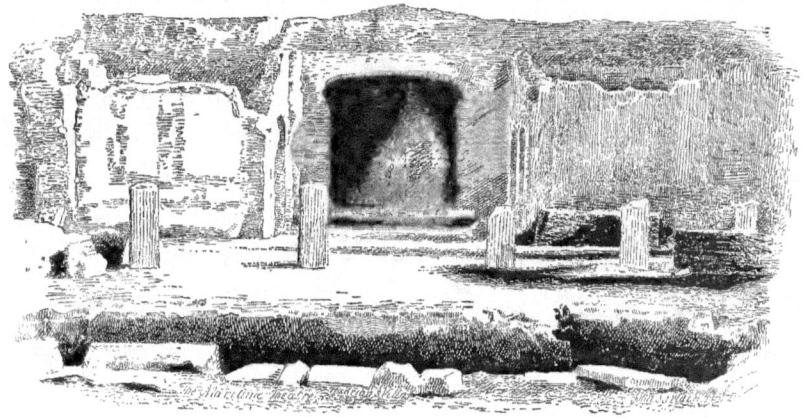

MARITIME THEATRE, HADRIAN'S VILLA

The charm to the eye of encaustic or wax painting, makes it probable that it was practiced as long as the Græco-Roman traditions lasted.

"In the villa of Hadrian near Tivoli," says Böttiger, "distinct traces of it are found."

It must have been well known, for in the pandects of Justinian materials for wax painting were specified in the legacy of a painter, among them the peculiar *cauteria*; which are the same as the "*vas ferreum*" of Pliny and Vitruvius, namely, charcoal braziers for heating the stylus and colors, and for burning in the picture. Also in a later Roman and Byzantine time, even into the twelfth

century, this method of painting continued to be occasionally practiced. After that there is no trace of it and it would appear the art was totally lost.

Even if it was known there until the capture of Constantinople by the Crusaders in 1203, the transplanting a knowledge of the art into the western countries did not follow.

"From the latest time of the Byzantines," says Böttiger, "until the middle of the eighteenth century, we do not find a single trace of encaustic," and with perfect right he doubts the so-called vestiges of it in the sixteenth and seventeenth centuries.

The painters of the Renaissance did not know it; before the discovery of oil painting they worked exclusively in fresco and tempera. However, from the inscription of a painting of 1520, representing Martin Luther, the work of Lucas Cranach, it was attempted to show that this artist understood the ancient process.

Daniel Neuberger also is said to have practiced it, and in 1654 to have painted with wax colors, in a book of genealogy of the optician Cosmos Conrad Cuno, a picture of Moses. Yet both statements lack authentic support, and everything gives us reason to suppose that before the middle of the eighteenth century a knowledge of it had utterly disappeared.

About that time first began the attempts at the restoration of encaustic painting. The first who busied himself with it with earnestness was the well-known Count Caylus (Philippe Claude de Tubières), whom the Flemish painter John Jacob Bachelier, the Cavaliere Lorgna of Verona, Taubenheim, Halle and Koslie followed.

In the year 1769 the Electoral court painter, Benjamin Calau, gave in Leipsic instructions for rendering the Punic (that is mixed with natrum) wax fluid, and to mix it with all kinds of oil and gums, as well as with pigments.

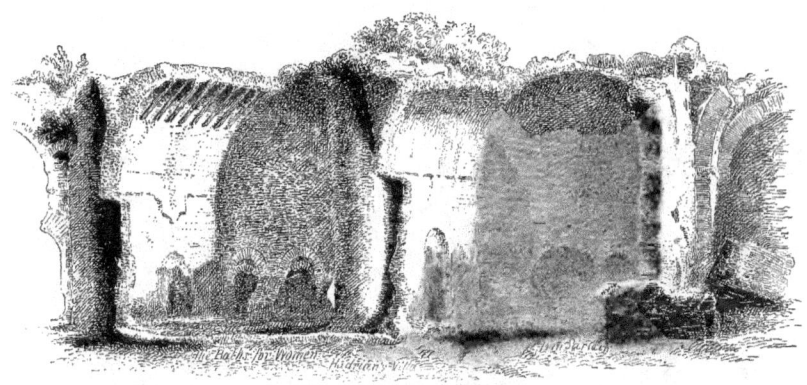

BATHS FOR WOMEN, HADRIAN'S VILLA

New attempts and discoveries were made by Colebrooke, John Frederick Reifenstein, Hackert, the Spanish ex-Jesuit Don Vincentio Requeño, who in 1784 wrote a work upon it, also the already named Tuscan Fabbroni and others made attempts on which Goethe passed a rather unfavorable judgment. In our century Montabert, Wiegmann, Knixim, Fernbach and others followed.

The last named, who in a work issued by him in 1845, has stated the results reached by him in the most circumstantial manner, has also according to his assertion, made successful attempts in using encaustic upon stone. After the surface of the stone to be painted was sufficiently heated, and in this condition smeared with a strong solution of amber, he passed over it two coatings of a solution of wax with turpentine, resin and amber.

The outlines were drawn on this ground, and then with a brush the colors were put on, mixed with wax, caoutchouc, or amber, and oil of turpentine; finally the whole was treated with varnish, and waxed. The varnish consisted also of a mixture of thick turpentine, resin and wax, which was renewed two or three times after drying, then uniformly melted by heating, and at last, after drying two or three days, was polished with brushes and linen cloths.

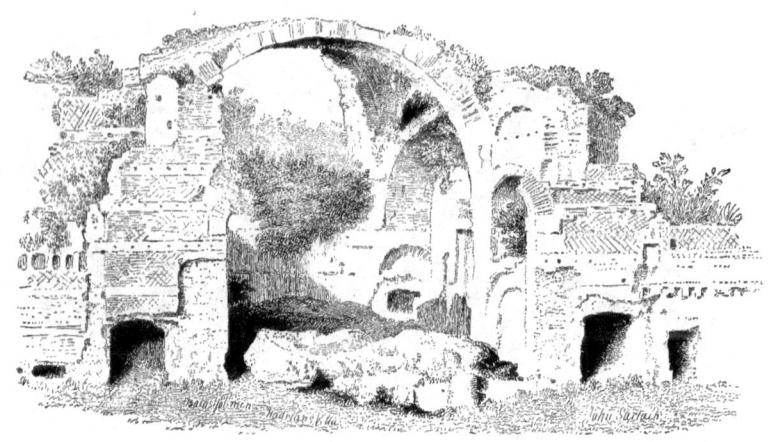

BATHS FOR MEN, HADRIAN'S VILLA

Aside from the use of the brush, this is, on the whole, the same method which the ancient encaustic artist appears to have employed. Also, in later times, here and there attempts have been made at wax painting. So what is found of encaustic painting belongs either to the last century or to antiquity.

For a long period of time the only known encaustic tablet picture of antique origin was a half-length figure of the Muse Polymnia, now in the Museum of Cortona, but for more than a century previous had been in the possession of the Tommasi family. This was found near Centoja, between Chiusi and Montepulciano, and after singular adventures came into the possession of the community of Cortona.

It is painted in a peculiar manner upon a tablet of slate, and by its moderately good execution, and the similarity with the Pompeiian paintings, may be considered, as Dennis considers it, undoubtedly a Greek or Roman work.

But in the year 1818 there was discovered a second and far more important example of antique tablet painting in encaustic, and after a succession of tests and the closest scrutiny and research by well-qualified experts, and subsequently of my own,

I feel confident in the assertion that from internal and external evidence, there can be no reasonable doubt of the genuineness of this remarkable picture, and of its high historic and art-historic value.

In medias res intro. In the course of last autumn the well-informed Abbe Casola, at Sorrento, who was often my companion in my rambles in that part of the country, proposed that we should visit his friend, the Baron de Benneval, in the Piano di Sorrento, in order to see an ancient painting which had been long in his possession.

Naturally I accepted, and one beautiful morning we had ourselves announced in the charming villa of the French nobleman. The possessor received us with exquisite complaisance, and soon we stood in a small salon before the strange picture, which represented Queen Cleopatra in half length and life size, and in the act of applying the asp.

I confess that at the first glance I hesitated to accept the antique origin of the picture, and for two reasons: On account of the freshness of the colors and the good preservation, and especially of the physiological truth of expression in the countenance.

Yet this impression, natural to the novelty and variety of the phenomenon, yielded to a more searching examination into other qualities of the picture, and was changed into a firm conviction of the contrary, the more the facts of ancient art arose in my memory, and the more the picture displayed features allied to undoubted antique work.

We begin with an accurate description of the picture in order thus to unite with it the evidences for its antique origin, which, so far as they are of a technical nature, are referable to the foregoing analysis of encaustic painting, and justifies its fulness of detail. The picture is — an important factor — like the Muse of Cortona, painted upon a tablet of slate which, without the frame, has a

height of 79 cm and 57 cm wide. An examination is said to have shown that the slate is oriental.

The figure painted upon a dark green background, representing a curtain, and without any other accessories, is visible from the crown on the head to the middle of the body, and measured 65 cm in height and 45 cm across the shoulders.

The face is 19 cm long, the right hand with slightly bent fingers 17 cm long. The figure is represented full front, the head alone turned slightly to the right.

She is clothed in a purple-red chiton, which is bound in a knot on the right shoulder, and leaves free the arm as well as the left half of the whole chest.

The right arm is bent in a right-angle, the forearm being strongly foreshortened, and a very elegantly formed right hand holds loosely some folds of the chiton, which evidently is intentionally removed from the left breast.

On this one sees the dark green, yellow-spotted snake, which, applied to the breast with the raised left hand, has wound itself around the forearm, and inserted its teeth into the left breast, from which some drops of blood ooze out. Outstretched, the snake might measure perhaps 70 cm.

Upon the head of the Queen rests the crown of the Ptolemys, which is simple, and of gold, and between every two points there is a pearl. Upon the middle of the forehead is a jewel set in gold and surrounded by four pearls, which apparently hangs from the crown, but really is held by a very fine gold chain wound round the head.

The full blonde hair, strewed like the eyebrows with gold powder, is laid around the head in artistic braids or tresses, makes a moderate sized knot on the top of the head, and falls loosely down upon the neck. Two braids are wound round the head, and

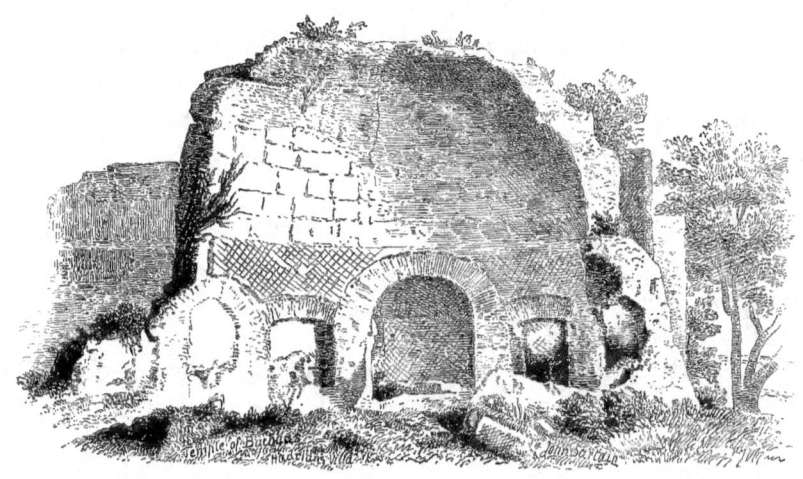

TEMPLE OF BACCHUS, HADRIAN'S VILLA

are bound together in front of the chest in a knot. To the ears are suspended earrings which consist of a jewel surrounded with pearls. The neck is adorned by a collar falling down to the bosom, made of large alternate green and red jewels and great pearls.

The adornment is completed by two bracelets on the right arm. The one tightly clasping the upper arm consists of an ornamented band of thin gold set with jewels, three centimetres in breadth, from which large pearls hang by gold cords.

Three broad rings of twisted gold loosely encircle the wrist. The fingers are without rings.

The figure is moulded very full. The limbs show roundness and softness; of peculiar elegance is the shape of the forearm and the hands, which have long pointed fingers with small oval nails. Conspicuous, but entirely corresponding to the ancient style of configuration is the considerable breadth of the shoulders and the distance between the breasts.

The neck is slender and yet strong, the head proportionately small; the oval of the countenance and the long straight delicate

nose are purely Greek. Most remarkable is the expression of the face, which shows considerable ability on the part of the artist in representing physiological and psychological appearances. The original leaves no doubt that the artist intended to represent the sudden pain which followed the poisonous snake-bite.

The eyes of a deep dark blue, almost black, are turned upward with an expression of repressed suffering, so that the pupils half disappear beneath the upper eyelids.

The nostrils are drawn in; the mouth is open as in one who is obliged suddenly to stop the breath. It is apparent that the poison has already taken effect and must soon destroy the beautiful structure.

The picture was found, broken into sixteen fragments, among the ruins of Hadrian's villa, by a Florentine gentleman who had purchased a portion of the ruins.

From the Roman mortar found adhering to the back it had been probably let into the wall. He instituted a chemical examination of the pigments and vehicles used in it, and the result is in the highest degree interesting.

Concerning the importance of this document we refer to the report of the Marquis Cosimo Ridolfi made in 1822 to the Professor Petrini, which was printed in the "Autologia" at Florence in the same year.*

The Baron v. Liebig read this analysis, and many times examined the picture and expressed himself as fully satisfied of its antique origin.

This report is a valuable contribution to the history of the picture, and shows that soon after its discovery men of professional eminence occupied themselves in examining it, and never ques-

*See page 21.

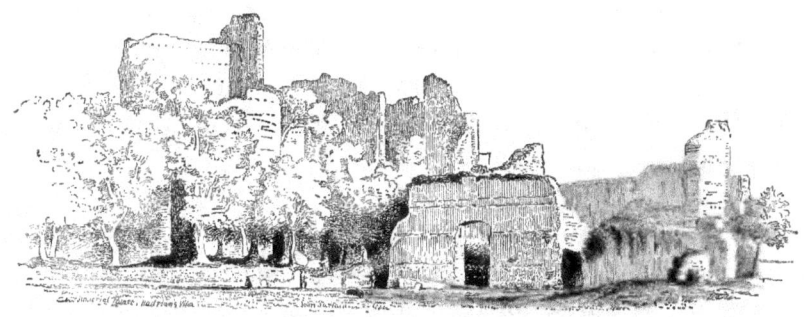

PART OF THE HUNDRED CHAMBERS, HADRIAN'S VILLA

tioned its authenticity. The manner of its execution corresponds exactly with the ancient mode of encaustic painting described in the earlier pages of this paper, and that this method was lost from the time of the decay of ancient art until the latest times is generally conceded.

We have already spoken of the remarkable breadth of the chest; also of the neck which is somewhat Juno-like, the oval of the face and the Greek nose.

The garment is disposed in a manner that reminds us of the style of ancient statues. The knots of the mantle are similar to what is seen on the left shoulder of a so-called bust of the younger Faustina upon a topaz cup at Gastoni; upon the right shoulder of another female bust; the armless girdled chiton on a relief which represents a sleeping nymph surprised by a Satyr, is bound in knots on both shoulders.

One also sees two knots of the chiton on the shoulders of a Juno in the Gallery Giustiniani, and also on another female figure there.

The indented crown is that of the Ptolemys which are also seen upon the coins of Ptolemy V Epiphanes, Ptolemy VIII Soter, and others. The jewels are of antique form, and the manner in which they are painted is identical with that of many Pompeiian

mural paintings. An ornament like that adorning the forehead of the Queen is worn by a Kanephore of the Vatican on a necklace. Two earrings of a jewel (amethyst) set in gold and surrounded with five pearls, are found in the Vienna Cabinet of coins and antiquities.

The red jewels of the Queen's neck-ornament can be only rubies or garnets, the green ones emeralds. Garnets, emeralds and agates are found in a collar of gold fillagree in the Fould collection.

A neck-chain of gold with ten small emeralds, four garnets and five sapphires, is found in the Cabinet of antiquities at Vienna. It is eleven and three-quarter inches long and comes from Herculaneum and was presented by the King of Naples to Prince Khevenhüler.

The armlet consisting of several small rings, is found, particularly on the right arm, in several of the Pompeiian dancing women, and also in numerous vase figures.

In a Pompeiian painting of "The Finding of Ariadne by Dionysius" the divinity of the place sitting aloft at the left, has on the right upper arm a broad band-like armlet similar to that in the picture and also on the wrist a smaller one wound around several times.

The knot which is formed by the tying together of the two braids of hair in front on the neck appears to be unique of its kind. At least I have been unable to find any other example.

But the abundant hair hanging over the shoulders is often found; for example, in the Dionysius and the Bacchantes.

A head of a Bacchante upon a gem shows, as in the Cleopatra, loose hair hanging behind, and a plait of hair the end of which falls down upon the breast. Two such braids are seen in the above-mentioned figure in the Gallery Giustiniani. The snake, in

the opinion of some connoisseurs, among them Col. Novi, Secretary of the Royal Society for the Encouragement of Commerce at Naples, is not a European viper but the oriental Naja.

Next to the evidence of the painting-technique appears the strict accord with the spirit of antique art. The quiet attitude even in suffering, the sparing use of powerful emotions and strong play of countenance is a conspicuous feature characterizing the ancient manner.

Only in this spirit could their conceptions take form and this is seen in the emotionless and passionless Cleopatra, thus uniting the tragic event of violent death with epic treatment and an almost portrait pose. The treatment of the subject by every modern artist would be the reverse of this.

All that the creator of this picture allowed himself in the direction of truth to nature and realistic expression, is the painful opening of the mouth, the drawing in of the nostrils and the dying look of the turned-up eyes.

That he was not without the talent for pathological expression is thoroughly proved by these. But he did not wish to go further in it, and therefore remained imprisoned in the genuine antique one-sidedness and imperfectness of the expression of emotion. There is no violent action, no contortion of the face which could affect the regularity of the lines!

The impossibility of preserving a quiet attitude and mien while dying of a snake's bite, which would be one of the first considerations of a modern, was not regarded by the ancient artist, with whom the demand for moderation and repose stands unconditionally in the first rank.

Hence the attitude of Cleopatra, which could not be more motionless and composed if the Queen had studied a dignified pose before the mirror. Hence the full front view of the body which

does not show the least turning, quivering or relaxation. Hence the studied position of the hands; the right one does not appear to really grasp the garment nor the left show the intention of holding the snake firmly.

If one did not see the face one would discover in the whole figure no trace of the death agony.

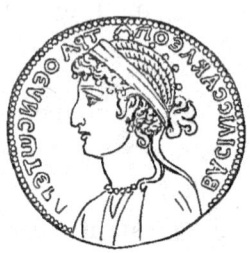

CLEOPATRA COIN PRESERVED IN THE BRITISH MUSEUM

Among the questions which arise concerning the picture, is that of its resemblance as a portrait, or what is the same thing the correspondence of the features with those of recognized portraits of the Egyptian Queen. Authentic, but rather imperfect representations of Cleopatra we find upon several contemporary coins; a tetradrachma probably struck in Alexandria in the year 33 before Christ or soon after, and a Roman silver coin, according to Visconti, of the year 34 before Christ.

The first shows upon the face the profile of Mark Anthony with the Greek inscription "Antonius for the third time Imperator Triumvir," upon the reverse a bust of the Queen with artfully arranged hair surmounted by a diadem, in a royal mantle which is held together upon the right shoulder by a clasp adorned with precious stones.

The inscription reads "Queen Cleopatra the new Goddess." The Roman coin shows the same heads with the inscriptions "Anthonius after the conquest of Armenia" and "Cleopatra, Queen of Kings whose Sons are are Kings."

ANTIQUE PAINTING OF CLEOPATRA

In all these heads the features of the renowned Queen are not beautiful, at all events much less pleasing than they must have been in reality, though we know through Plutarch that her beauty was not of the first rank, and her charm consisted more in the union of pleasing ways with talents.

She appears somewhat old, with the tip of the nose slightly pendant like other Ptolemys. The heads on the coins are in profile, and hence, a comparison with the Sorrento picture showing the full face is difficult, and one cannot be surprised at any lack of resemblance, and all the more that the coins are imperfect and defaced while the painting may be in a measure idealized.

Of the portraits of Cleopatra neither those that are supposed to be authentic nor those that are certainly known to be so, show similarity to the heads on the coins nor to each other. In a marble head in the Capitoline Museum one can perhaps discover in the rounding contour of the face, the regularity of the features and the strong neck, a similarity to our painting.

The marble head of a dying woman with a diadem who inclines her head somewhat to the right and opens the mouth in a similar manner described by Bergerus and called Cleopatra, is probably a Niobe, to which also the classically noble lines point. A bronze statuette described by Caylus, which without special reason is considered a Cleopatra, Raoul-Rochette declares to be a Thetis.

Quite numerous are the cut stones upon which portraits of the Egyptian Queen are believed to have been dis-

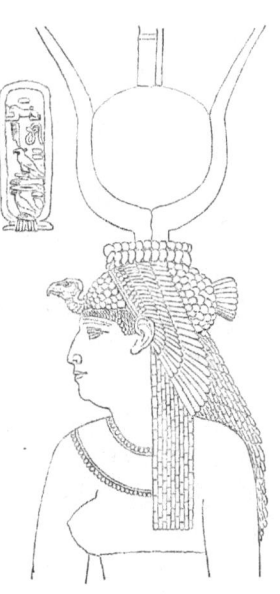

CLEOPATRA, FROM THE CARVING ON THE PRONAOS OF THE TEMPLE AT DENDERA, EGYPT.

covered, principally on account of the snake which is represented sometimes in her hand, sometimes on her bosom, sometimes beside her.

A female portrait head described by Fulvius Ursinus and Stosch, considered by the first to be a Hylas (!) on account of the Greek inscribed name of Hyllos (the well-known sculptor), Stosch declares to be a Cleopatra on account of its agreement with another portrait of the Queen, which Ursinus also calls a Cleopatra. Indeed both pictures show the most perfect resemblance to each other.

The profile, turned in one toward the right, in the other toward left, has in both cases the same expressive character, more spirited than pleasing. Also the fashion of the hair with the locks falling on the shoulders and the diadem are the same.

On the contrary one seeks in vain for a similarity in an undraped half-length with long waving hair and a snake on the bosom, upon a cut jacinth of Bergerus; also in a beautiful head with a laurel wreath, full face, and snake, upon a sardonyx in the Museum dei Medici. Whether a cut carnelian of the Museum in the Collegio Romano really represents Cleopatra is as uncertain as in the above-mentioned cases. The delicacy of the face joined with a long straight nose which somewhat hangs down, as also the sceptre over the left shoulder, renders it probable.

I will now bring together and compare the ingredients discovered by Ridolfi in the Sorrento picture, with the statements of Pliny, and the chemical examination of other antique colors. A simple dry inventory of the sentences of the authors and chemists will speak most distinctly.

Concerning the color we find the following statements: — Pliny: "For wax colors for encaustic painting they use three colors," namely, "purple-red, indigo, Egyptian blue, white lime earth (calcareous earth), arsenic yellow, appianum and lead white." Mi-

gliarini: "The white (of Egyptian painting) is not lead white, but a very fine and pure calcareous earth."

Sir Humphrey Davy: "The white (in the colors of the Baths of Titus and the Aldobrandini Wedding) is chalk or a fine clay." Ridolfi: "A very beautiful white lime made the chiaro-scuro and the reflected lights."

Concerning the yellow color, Migliarini says: "The yellow (of Angelelli's Egyptian color experiments) is iron ochre." Chaptal found yellow ochre in Pompeii. Davy says: "The yellow is ochre sometimes mixed with oxide of lead and chalk." Ridolfi says: "A yellow ochre is used to represent the gold of the jewels."

Concerning the red colors, Migliarini: "The red of a very beautiful tone is tritoxide of iron." Davy found three kinds of red: a bright red approaching orange, consisting of vermilion or red oxide of lead, a dark red and a purple red, both composed of iron ochre, also cinnabar upon the walls. Ridolfi says: "Tritoxide of iron made the red of the Cleopatra mantle; vermillion was used in the folds."

Finally, concerning the green colors, Migliarini says: "The green was mostly a green earth." Chaptal says, "The green is a mixture of green earth." Davy says: "One green approaches olive green and is common Veronese green earth. Another is like carbonate of copper mixed with chalk. A third consists of a green copper composition with blue copper frit." Ridolfi says: "A mixture of green earth and carbonate of copper forms the green color."

It must be acknowledged that the result of the foregoing comparison could not be more favorable. In the Sorrento picture exactly the same colors are used that appear most frequently in other antique remains, and it has no single color which was not known in antiquity.

ANTIQUE PAINTING OF CLEOPATRA

PORTION OF A ROMAN TRIUMPH.
(AFTER THE ANDREA MANTEGNA, AT HAMPTON COURT PALACE.)

ANTIQUE PAINTING OF CLEOPATRA

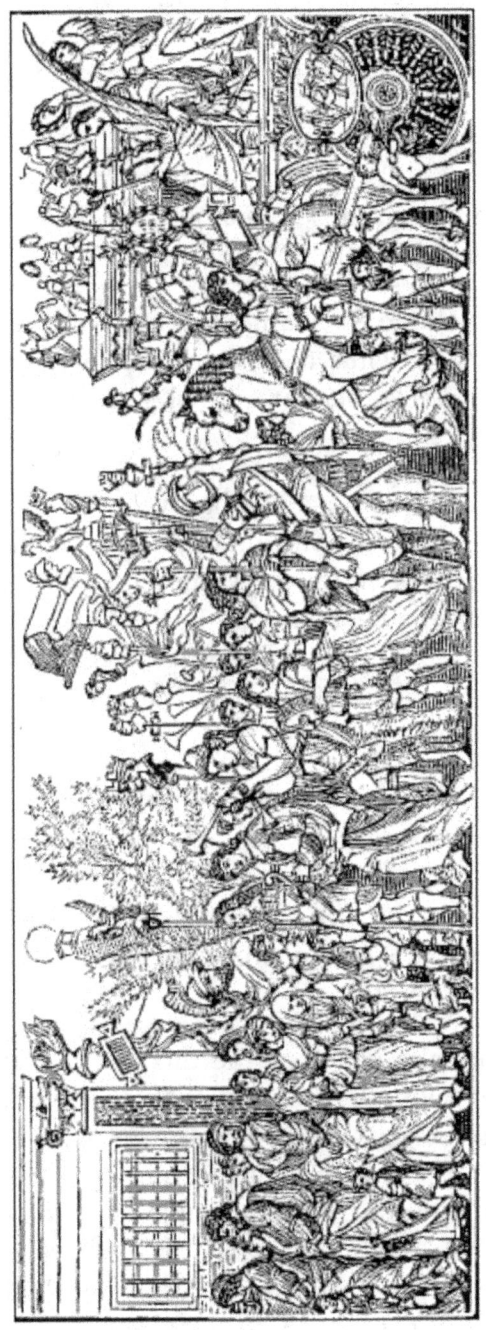

PORTION OF A ROMAN TRIUMPH.
(AFTER THE ANDREA MANTEGNA, AT HAMPTON COURT PALACE.)

The same is the case with the vehicles. According to Ridolfi's analysis the vehicle in the picture of Cleopatra consisted of a mixture of one part wax and two parts of mastic resin.

That an organic vehicle has not been discovered in all ancient color remains but only in comparatively few, is naturally explained by the fact that those remains are mostly wall-paintings in which such vehicles were not used.

Indeed Chaptal and Sir Humphrey Davy in the colors from Pompeii, the Baths of Titus, and those of the Aldobrandini Wedding found no vehicle, neither animal glue, nor albumen, nor wax.

Also Prof. John of Berlin could discover in the Pompeiian colors neither glue, wax nor resin, although he recognized traces of organic ingredients — in the Egyptian colors also, animal glue. The French chemist Chevreuil who in the forties made and described new analyses of Roman color remains, says that he found considerable traces of organic materials although neither fat, lime, egg, gum, wax, nor resin.

Professor Geiger of Heidelberg published in 1826 his chemical analyses with explanatory remarks by Roux. Both say they have discovered animal glue and wax in old Egyptian as well as in Roman colors; but, on the contrary, Donner believes that they analyzed pieces which had been additionally gone over or varnished with wax or turpentine.

As far as specially concerns the mixture of wax and resin, we know through Pliny and Vitruvius that different tree resins, among them mastic, and the resin of the Pistacia Lentiscus were used; through Rosellini, that the Egyptians used for encaustic painting a mixture of wax and naphtha; through Pliny and Dioscorides, that a mixture of wax and resin was used in ship painting. Geiger says wax and resin were mixed with Egyptian colors, and Knixim believes that he can make a statement con-

cerning the proportions in the mixture, which agrees with Ridolfi's analysis of the materials found used in the Sorrento picture as set forth in his report.

The Baron v. Liebig read the analysis by Ridolfi of the materials used in the Cleopatra, and having examined the painting many times was fully satisfied of its antique origin.

In 1851 a number of painting materials were found at Pompeii in the Street of Stabia, among which, besides the colors, were pieces of asphaltum and resin, a mixture of asphaltum and pitch, and great piece of bright yellow ochre which contains pieces of a resin resembling pine or fir or spruce.

In the tomb of a Gallic-Roman female artist near St. Médard des Près were found, beside painting boxes, brushes and colors, also a glass vessel with a piece of resin which Chevreuil takes to be either pine or fir or pitch resin, also in one phial wax, in another wax mixed with resin, and in a third a black color mixed with wax and oil.

No further proofs are needed of the agreement of the technique of the Cleopatra with the technique of antiquity.

There remains to us still to consider the question of the authorship of the picture and the immediate circumstances of its origin. We are not prepared to answer the first. For the opinions expressed, according to the statement of Nagler's Art Lexicon, in the "Vienna Journal of Art-Literature" for 1824, which probably is only a repetition of Tanucci's and upon whose authority it has often been repeated, is without sufficiently satisfactory foundation.

They would be without it even if it were proved that Timomakos was contemporary with Cleopatra. Pliny says very distinctly "Timomakos of Byzantium painted in the time of the Dictator Cæsar an Ajax and a Medea which were purchased by Cæsar

at the cost of eight talents† [*An Attic talent was equal in value to sixteen of the Roman] (three hundred and thirty thousand marks) and were placed by him in the temple of Venus Genetrix." Now this statement may rest upon an error of the not always accurate copying scribe, who may have confounded the fact of their purchase by Cæsar with that of the contemporaneous production of the pictures.

The purchase and dedication to Venus he mentions in two other places. "The Dictator Cæsar bought two paintings for eighty talents, namely the Ajax and the Medea of Timomakos in order to place them in the temple of Venus Genetrix as consecrated offerings," and "The Dictator Cæsar exposed the pictures to public view by placing them in front of the temple of Genetrix as votive gifts."

If the immense price is difficult to reconcile with the admission that the pictures were by a painter then living, this becomes yet more doubtful through the statement of Pliny that the Medea was unfinished. It is possible that the two pictures mentioned by Cicero as existing in Kyzikos, Ajax and Medea, which already in the year seventy had obtained a world-wide reputation may have been the same that Cæsar purchased, in which case they could not have been painted during his dictatorship.

Pliny appears to have made another mistake when he said that the inhabitants of Kyzikos sold an Ajax and a Venus to Agrippa.

We do know that a picture of Cleopatra was really painted after her death at the command of Augustus, in order that it might be carried with him in his Triumph after his victory over Egypt. It is even proved that this picture represented the Queen as she appears in the one now at Sorrento, from which it becomes all the more probable that if it is not the original, it is at least an ancient replica of that very painting.

† An Attic talent was equal in value to sixteen of the Roman

It can be readily understood that there should have circulated, as Plutarch states, different versions of the manner of the Queen's death, of which only a few intimate confidants could have had positive knowledge.

Some say that the viper was smuggled into the room in a water jar; others say in a basket of figs. It is related that she had the viper brought in hidden from view, so that she might not be terrified at the sight of it, but be wounded by it without seeing it; while another contradictory account narrates that she irritated the creature into biting by pricking it with a spindle.

Yet another version says the Queen died, not by the reptile, but by poison that she kept concealed in a hollow reed that she wore in her hair. Plutarch and Dio Cassius, whose accounts there is no reason to doubt, agree in the statement — and this is not without an important bearing on our subject — that Cleopatra "gave herself to death in full royal array."

After she had deceived Octavius and his envoys in a clever manner as to her intentions, and had given the freedman Epaphroditus a letter to the Roman generals in which she again begged them to let her be buried near Anthony, "she put on her most beautiful dress and ordered everything in the most sumptuous manner, and gave herself to death in full royal array."

They found her dead lying upon a golden couch in royal array. Of her women, one whose name was Iras, lay dying at her feet, but the other, Charmion, although she already tottered and her head swam, was engaged in setting right the diadem upon the head of the Queen."

All this we see corresponds with the picture, and the agreement goes still further.

Plutarch says that on entering the death room, they found neither the snake — to which according to his account she had

offered her bare arm — nor any distinct traces of the mode of death.

"Neither swelling of the body nor any sign of poison was apparent. Neither was the viper seen in the room, but they saw, as is said, some traces of it on the sea-shore, in which direction the windows of the room looked."

We know that Cleopatra had watched experiments of the effect of adder poison on condemned criminals.

"She saw that, almost alone, the bite of the adder produced a deathlike sleep without convulsion or cry of pain, that the subject was to a certain degree paralyzed, having a slight perspiration on the face and a weakening of the mind, and could only be aroused with extreme difficulty, like those in a very profound slumber."

"Some say the arm of Cleopatra showed two small and hardly perceptible punctures."

"Only fine punctures were found on her arm."

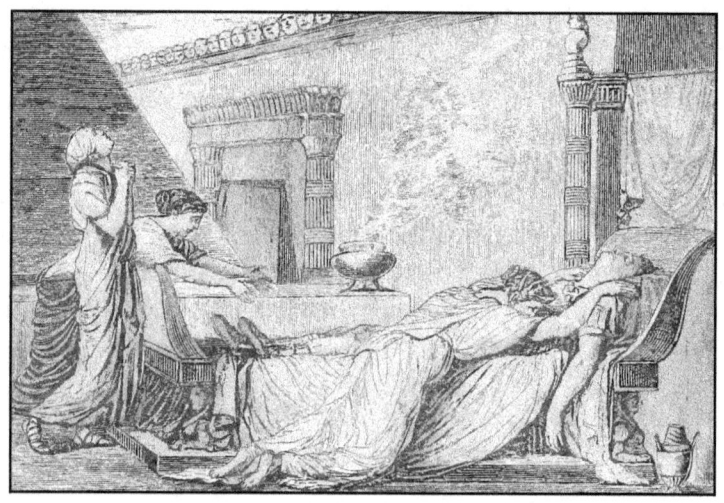

DEATH OF MARK ANTHONY.
(AFTER MIERIS).

From all this we must conclude that she received her death from the poisonous reptile, "and the emperor himself appears to have entertained this opinion, for at his triumph a picture of Cleopatra with a firmly biting snake was carried."

Certainly it is beyond doubt that a picture like the one under consideration was painted at that time for the above-named purpose by command of Octavius, so that she might, in a manner, be seen in his Triumph along with the other prisoners of war.

It will not be denied that the Sorrento picture corresponds with these documentary records, showing the same features that are mentioned in the accounts of Octavius' picture.

Here as there "the firmly biting snake;" here as there "the representation of the dying," then as here without doubt the full royal array of which all accounts speak, and which from external reasons could not have been absent in the picture carried in the Triumph on a litter with other valuable objects of Egyptian booty found in the chamber of death.

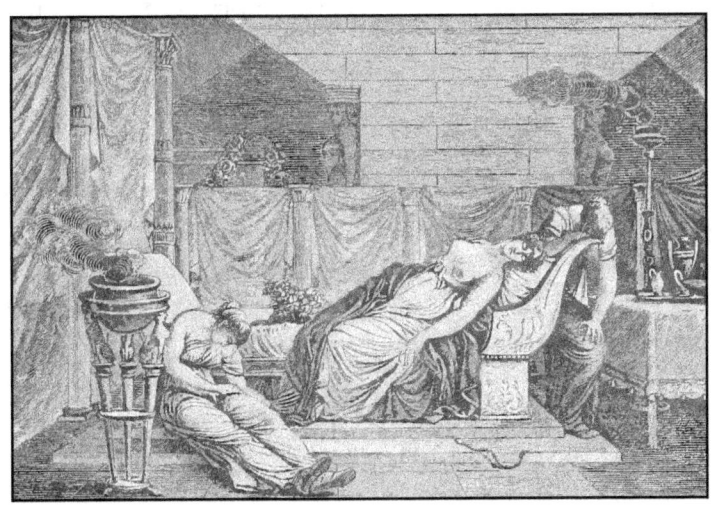

DEATH OF CLEOPATRA.
(AFTER MIERIS).

All things considered, we are fully justified in pronouncing the pictures identical.

It is true Appian states that Octavius had consecrated in the temple of Venus "a beautiful picture of Cleopatra" which was still there in his time.

This may have been the Sorrento picture or it may have been a replica. Hadrian enriched his villa by preference with productions from Greek artists, and would naturally desire, above all, to possess an original picture of the last sovereign of that country for which he cherished a particular affection, and whose incorporation into the Roman empire was so closely connected with the destiny of its last queen.

We know that the Emperor Hadrian, who in his villa desired to rest from the cares of government, and carry on his favorite amusements, busied himself especially with art and in collecting objects of art.

"He erected palaces and devoted himself to collecting statues and pictures," making it his chief aim to bring together there the curiosities which he had met with in his extensive travels, the originals when they were to be had, and when that was not possible, copies.

Nothing more natural than that he, who had erected a vast complex structure in the Egyptian style called Canopus, and filled it with Egyptian statues and pictures, should also desire to have a picture of the last Queen of Egypt, and so had this historic curiosity removed from Rome to his villa.

A personage so connected with Roman history could not lack interest for him. Her close connection with the greatest figures of the beginning of the empire, her advantages of mind and body, her dazzling appearance and her dramatic entrance into public notice, her life rich in luxury and change, her crime and its atone-

ment, her greatness of soul and her tragic death — all this must give her figure a high historical relief.

From the excellence of the execution of the painting no one can draw an argument against its ancient origin. To-day it is no longer necessary to combat the opinion that ancient painting occupied a low level.

The preserved ancient paintings including the mosaic pictures, which — although mostly only weak copies by inferior artists and art workmen — still surprise by their excellence in technique as well as by their art and grace, leave no doubt that painting, until and into the beginning of the Empire, stood upon a high level.

To this are added the explicit statements of the old writers, which show that a greater admiration was given to many productions of painting than to those of architecture, the unsurpassable greatness of which cannot be disputed. Numerous expressions show that the great painters enjoyed an almost boundless fame, that many pictures had a world-wide renown, and that they were often sold for enormous prices.

Undoubtedly in Alexandria and other parts of Egypt there were not wanting artistic and costly statues and pictures of Cleopatra as well as of Anthony, which were executed either at the instance of the ostentatious royal pair or in homage to them. The statues of Anthony were thrown down everywhere immediately after Octavius' victory.

Those of the Queen were spared this fate, because one of her familiar friends bought from the conqueror, by the payment of two thousand talents, permission to let them stand. Nevertheless we cannot wonder that only few representations of her remain. She was a vanquished enemy of the Roman people, a personal opponent of the family of the Emperor, whose sister, on her account, had suffered a bloody abasement, and it was not fitting to

preserve her portraits. The later destinies of Egypt also, outside of which undoubtedly only few of these portraits could have existed, were peculiarly unfavorable to the preservation of them.

Herewith we must close. The rarity of authentic representation of Queen Cleopatra can hardly heighten the value of this Sorrento painting, so remarkable in every respect, that it is reasonable to predict that at no distant day National Museums will contend with each other for its possession.

THE END.

www.ingramcontent.com/pod-product-compliance
Lightning Source LLC
LaVergne TN
LVHW020434080526
838202LV00055B/5184